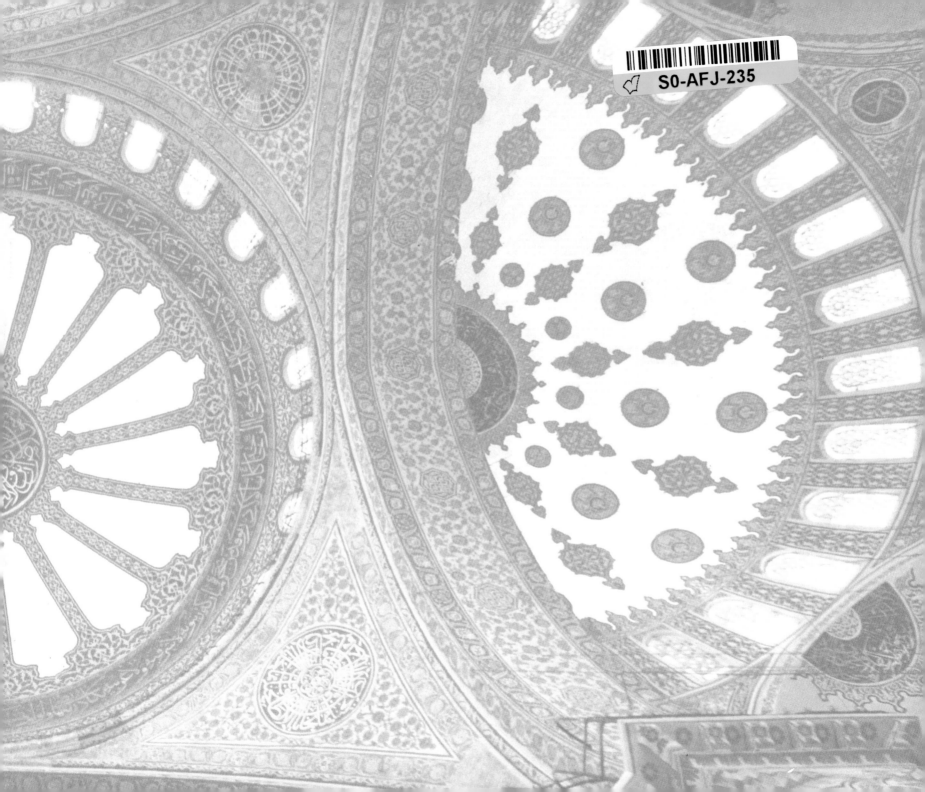

Istanbul
City of Two Continents

For Laura B.
Again. Because.

◆

Istanbul

City of Two Continents

JOHN CLEAVE

Introductions by JOHN FREELY

Editions Didier Millet

PRONUNCIATION

The modern Turkish alphabet and its pronunciation differs from English in a few cases. Below is a guide to pronunciation. A Glossary of Turkish words used in this book is on page 93.

A, a	as in cart
C, c	as the j in jacket
Ç, ç	as ch in chance
E, e	as in bet
G, g	hard, as in get
ğ	silent, lengthens preceding vowel
I, ı	neutral, as a in about
İ, i	as in bit
J, j	as s in pleasure
Ö, ö	as ur in hurt
Ş, ş	sh as in sugar
Ü, ü	as u in the French tu

editorial director: TIMOTHY AUGER

editor: VALERIE HO

designer: TAN SEOK LUI

production manager: SIN KAM CHEONG

Colour separation by PICA DIGITAL, SINGAPORE

Printed in Singapore by STAR STANDARD

Illustrations, captions and gazetteer © JOHN CLEAVE
Introductory texts © JOHN FREELY
Design and typography © EDITIONS DIDIER MILLET 2008
First published in 2008 by EDITIONS DIDIER MILLET
121 Telok Ayer Street, #03-01. Singapore 068590.

www.edmbooks.com

ISBN 978-981-4217-52-1

ILLUSTRATOR'S ACKNOWLEDGEMENTS

Working on the vast, diverse, bustling and glorious city that is Istanbul has been for me a journey of discovery. And, as for all explorers, to make the journey at all has been possible only with the help of many people. To all those Istanbullus who have guided me, opened doors, and through their many kindnesses and courtesies have made my travels such a joyous experience, I am deeply indebted.

I owe special thanks to my good friend Sencar Toker who, after a night at the opera, made it all happen; to Hulya Baraz who never tired, it seemed, to show me hidden Istanbul; to Mehmet Konuralp who gave me a whole new view of the city; to my collaborator John Freely who so freely shared his vast knowledge of his adopted home; and to Sima Benaroya of Garanti Bank whose help from first to last has been invaluable.

Many gave access to the otherwise inaccessible, and guidance around the pitfalls of the Turkish language. My heartfelt thanks are due to Metin Ar, Maurice Asseo, Selahaddin Beyazıt, Trisha Carling, Ginesta & Alessandro Guerrera, Marko Hennis, Ingmar Karlsson, İzzet Keribar, Mme. Jean-Christophe Peaucelle, and Konstantinos Zaimis. And to Sabahattin (Sedat) Ülger, most knowledgeable of taxi-drivers.

But above all, and once again, my greatest debt is to my wife Laura who, both figuratively and literally has been with me every step of the way. Thank you, Lauramou.

John Cleave

The publishers gratefully acknowledge the generous support of the sponsors.

Illustrations
Endpapers: Dome above dome: the soaring ceiling of the Blue Mosque.
p. 1: The tuğra of the Second Caliph in the Süleymaniye Mosque reads: 'Omar, May God have him in His Grace'.
p. 2: In Üsküdar, on the Asian side.
p. 3: A window in Sirkeci railway station.
p. 5: On one side of sculptor Pietro Canonica's Republic Monument in Taksim Square, Mustafa Kemal Paşa, later to be Atatürk, leads fighters of the nationalist movement.

Contents

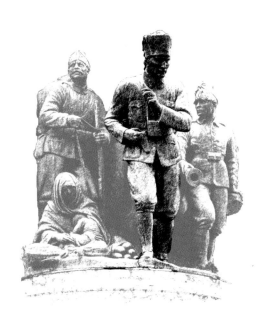

A City of Two Continents

Istanbul is the only city in the world that stands astride two continents. The historic heart of the city, which forms the southeasternmost extremity of Europe, is separated from its Asian suburbs by the Bosphorus, the incomparably beautiful strait that flows between the continents between the Black Sea and the Sea of Marmara in northwestern Turkey.

The European side of the city is further divided by the Golden Horn, a scimitar-shaped estuary that flows into the Bosphorus at its southern end, separating the Galata district on its north from the old city of Istanbul, known to the Greeks as Constantinople and the ancients as Byzantium. Thus the sixth-century chronicler Procopius was led to write that the city was surrounded by a 'garland of waters.'

The port quarter of Galata on the north side of the Golden Horn is linked with the old city by two spans, the Galata Bridge and the Atatürk Bridge. The Galata Bridge is the only one used by pedestrians, who for

more than a century have been crossing the Horn here between Karaköy in Galata and Eminönü in the old city, two of the oldest and most picturesque quarters in the city.

Eminönü has been a market quarter since the earliest days of the city, for it is on the shore of the original harbour of ancient Byzantium. This part of the Golden Horn, just below the Galata Bridge, still has the appearance of a harbour, for it is lined with the piers of the various ferry lines that steam up and down the Horn and the Bosphorus and cross the strait to the Asian suburbs and the Princes Isles in the Marmara, sounding their horns as they come and go, with flocks of seagulls crying out in their churning wakes.

Hundreds of amateur fishermen line the bridge, casting their lines into the Golden Horn, sometimes snaring passengers on passing ferries, while on the quays in Karaköy and Eminönü fishing boats sell fried fish sandwiches to passersby. Pedestrians going to and from the street markets

The emblem of Istanbul, designed in 1969 by Metin Edremit, symbolises the city. The divided semi-circle at the bottom represents the Bosphorus, which splits the city between two continents. The ramparts of the historic city are shown on each side. The iconic domes and minarets of Istanbul's mosques are silhouetted at the top and the triangles in the middle represent the seven hills on which the historic city was built. BÜYÜKŞEHIR BELEDIYESI means Metropolitan Municipality.

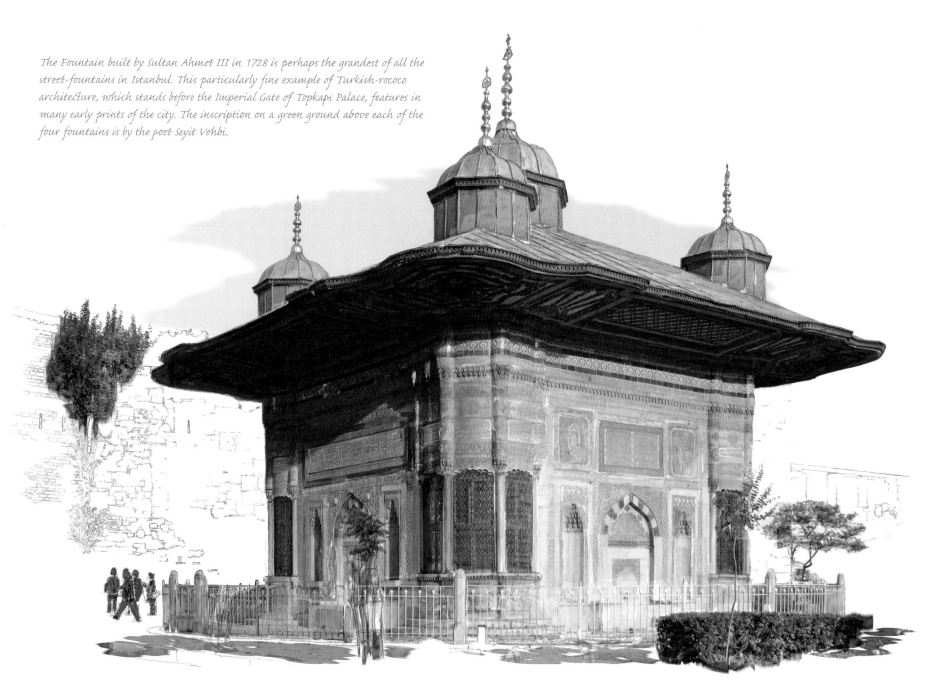

The Fountain built by Sultan Ahmet III in 1728 is perhaps the grandest of all the street-fountains in Istanbul. This particularly fine example of Turkish-rococo architecture, which stands before the Imperial Gate of Topkapı Palace, features in many early prints of the city. The inscription on a green ground above each of the four fountains is by the poet Seyit Vehbi.

in Eminönü run a gauntlet of peddlers hawking their ware above the roar of the traffic, some of them with amplifiers blaring out the latest arabesque love songs and old Anatolian laments, punctuated five times a day by the call to prayer from hundreds of minarets around the city, echoing between the continents.

Old Istanbul is a roughly triangular peninsula, bounded on its north by the Golden Horn, on its south by the Marmara, and on its landward side by the Theodosian Walls, the powerful line of fortifications built in the mid-fifth century CE by the Emperor Theodosius II.

The original city of Byzantium was a Greek colony founded ca. 660 BCE on the First Hill, the eminence that rises above the apex of the peninsula, at the confluence of the Golden Horn and Bosphorus, where their waters meet and flow together into the Marmara. Byzantium remained an independent city-state until 196 CE, when it was captured after an eighteen-month siege by the Roman emperor Septimius Severus, who destroyed the city and then rebuilt it within the next five years. One of the structures that he erected at that time was the Hippodrome, whose *sphendone*, or supporting wall, can still be seen, along with three

monuments erected along its *spina*, or central axis, in the late Roman era: the Egyptian Obelisk, the Serpent Column, and the stone obelisk known as the Colossus.

A new phase in the history of the city began in 330 CE, when the Emperor Constantine the Great shifted the capital of the Roman Empire to Byzantium, which was renamed Constantinople, the City of Constantine. The emperor greatly expanded the bounds of the city by building a line of defense walls from the Golden Horn to the Marmara, enclosing four hills. These fortifications formed the landward boundary of the city until 448 when Theodosius II built the walls that still bear his name. The Theodosian city was divided into fourteen regions and enclosed seven hills, the same as in Rome, six of them connected by a ridge that runs above the Golden Horn, the seventh rising to a peak above the Marmara shore in the southwestern corner of the peninsula. The topography was of great symbolic importance, for Constantine had issued an imperial decree calling his new capital NOVA ROMA CONSTANTINOPOLITANA, 'New Rome, the City of Constantine.'

Constantine built an imperial residence on the Marmara slope of the First Hill that came to be known as the Great Palace. This pleasure dome

was adorned, rebuilt and expanded by his successors up until the thirteenth century, when it was abandoned in favour of another palace at Blachernae, in the northwestern quarter of the city, where its remains can be seen built into the Theodosian Walls. When we first came to Istanbul in 1960, my wife and I and our three small children sometimes had picnics in the ruins of both the Great Palace and Blachernae, sites which at the time were inhabited by squatters, who were evicted after restoration projects began.

The main port of Constantinople was on the Golden Horn, in the district now known as Eminönü, the principal market quarter of city since the beginning of its history. Much of today's Eminönü is built on filled-in land between the Galata Bridge and Sirkeci Station, the terminus of the famous Orient Express. The bridge crosses the Horn to the Karaköy quarter of Galata, which was the thirteenth region of the Theodosian city, corresponding to the Trastevere region across the Tiber in Rome. The fourteenth region was Blachernae, where the land walls come down to the Golden Horn.

The city's water came from huge reservoirs outside the Theodosian Walls, conducted into Constantinople by aqueducts that led to the *nymphaeum maximum*, from where it was distributed to various parts of the inner city.

One section of the aqueduct survives within the city, a stretch of about 900 m carried on double arches across the deep valley now traversed by Atatürk Boulevard. The aqueduct was built ca. 375 by the Emperor Valens, and it remained in use up into the nineteenth century.

The water was stored in three enormous open reservoirs that can still be seen, as well as in numerous underground cisterns around the city. The largest of the latter by far is the Basilica Cistern near Haghia Sophia, known in Turkish as Yerebatan Sarayı, the Subterranean Palace. The cistern was rediscovered ca. 1550 by the French antiquarian Petrus Gyllius and was restored in the 1980s.

Some of the main thoroughfares of the modern city follow the course of roads laid down in late Roman Byzantium and early Byzantine Constantinople. Divan Yolu, the first stretch of the main avenue that leads from Haghia Sophia into the centre of the old city, was originally a colonnaded way built by the Emperor Septimius Severus at the beginning of the third century CE. The Portico of Severus, as it was called, became the first stretch of the Mese, or Middle Way, the central avenue of Byzantine Constantinople. The Mese ran along the spine of the Constantinopolitan peninsula passing through the Forum of Constantine and the Forum of Theodosius I. All that remains of Constantine's forum is an enormous porphyry column that he erected in 330, commemorating the founding of Constantinople, the New Rome. The column is now undergoing restoration. The ruins of the Forum of Theodosius I, built in 390, are arrayed along Ordu Caddesi, the continuation of Divan Yolu in Beyazıt Square, near where they were discovered during excavations in 1965.

At the centre of the city, the Mese split into two branches, one leading northwest to the Adrianople Gate, today's Edirne Kapı, the other heading southwest to the Golden Gate, a triumphal entryway erected in 390 by

Theodosius I and built into the Theodosian Walls in 448. Each of those gateways led to branches of the Via Egnatia, the great Roman road that led from Durazzo in Albania to Constantinople.

Shortly before his death in 337 Constantine was baptized as a Christian, and within the following century, Christianity became the state religion of the empire, while Greek replaced Latin as the official language. Thus the pagan Roman Empire of the West had become an eastern Christian Greek realm, which modern historians came to call the Byzantine Empire, because its capital was in the ancient city of Byzantium.

The Byzantine Empire reached its peak during the reign of Justinian (r. 527–565), whose general Belisarius reconquered parts of Italy from the Ostrogoths and took Carthage from the Vandals. Justinian was a great builder, the most famous of his foundations being the magnificent Haghia Sophia, the Church of the Divine Wisdom, erected in the years 532–7 along with Haghia Eirene, the Church of the Divine Peace, and the Church of SS Sergius and Bacchus.

Constantinople was captured and sacked in 1204 by the Venetians and the knights of the Fourth Crusade, who occupied the city until it was recaptured in 1261 by the Greeks under Michael VIII Palaeologus. The Palaeologues were the last dynasty to rule the Byzantine Empire, which though only a shadow of its former self nevertheless flowered in a remarkable cultural renaissance.

Earlier in 1261, Michael VIII had signed a treaty of alliance with the Genoese, who were given control of Galata. Soon afterwards, the Genoese began to fortify Galata, and in 1348 they erected the conical-capped tower that is still the principal landmark above the northern shore of the Golden Horn. Within the next century, the Genoese built defense walls extending down from the Galata Tower to both the Bosphorus and the Golden Horn, which in times of siege could be closed by a huge chain stretching across the harbour.

The rising power of the Ottoman Turks first threatened Constantinople in 1394, when Sultan Beyazıt I put the city under siege, building a fortress known as Anadolu Hisarı on the Asian shore of the Bosphorus at the narrowest point of the strait. The siege was lifted in the spring of 1402, when Beyazıt was forced to march his army eastward to confront a Mongol horde led by Tamerlane, whose army defeated the Turks and captured the Sultan, who died soon afterwards. Half a century later, in the summer of 1452, the young Sultan Mehmet II built a much larger fortress named Rumeli Hisarı on the European shore of the Bosphorus directly opposite Anadolu Hisarı. These two fortresses allowed Mehmet to control the Bosphorus in preparation for his siege of Constantinople, which began on 5 April 1453, when Mehmet arrayed his army outside the Theodosian Walls and began bombarding the fortifications.

The Byzantine Empire came to an end on 29 May 1453 when the city fell to Mehmet, who thereafter was known as Fatih, or the Conqueror. The city that he conquered came to be called Istanbul, a corruption of the Greek *stin poli*, meaning 'in the city' or 'to the city'.

Immediately after his Conquest of the city, which became the capital of the Ottoman Empire, Fatih converted Haghia Sophia into a mosque. Haghia Sophia continued to serve as a mosque throughout the remaining

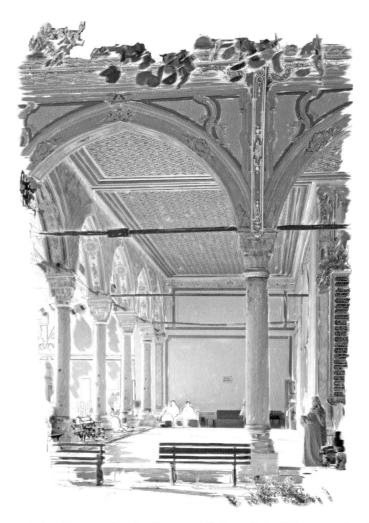

history of the Ottoman Empire, which ended in 1923 with the creation of the Turkish Republic under its first President, Atatürk. A decade later, Atatürk closed the mosque of Haghia Sophia and ordered that the building be converted into a museum, which opened in 1934.

Among the Byzantine churches converted into mosques are Zeyrek Camii, the former church of the Pantocrator, now under restoration, and the former churches of St. Saviour in Chora (Kariye Camii) and the Virgin Pammakaristos (Fethiye Camii); both have since been turned into museums to exhibit their mosaics and frescoes, a heritage of the renaissance of Byzantine culture in the fourteenth century under the Palaeologus dynasty.

Five years after the Conquest, Fatih built a large mosque complex outside the city on the upper reaches of the Golden Horn. The complex was dedicated to Eyüp Ensari, standard-bearer of the Prophet Muhammed, who had been killed during the first Arab siege of Constantinople in 674–8. Eyüp's remains had been miraculously discovered during the Turkish siege in 1453, and his tomb became the most sacred Muslim shrine in Turkey, surrounded by the picturesque village and cemetery that bear his name. Some of the old tombstones in the Eyüp cemetery have unexpectedly humorous epitaphs, such as one that says: 'Passerby, spare me your prayers, but please don't steal my tombstone.'

At around the same time, Fatih built a fortress inside the Golden Gate known as Yedikule, the Castle of the Seven Towers, which served to protect the State Treasury and was used as a prison for the ambassadors of foreign powers in times of war.

The first commercial foundation made by Fatih after the Conquest was the Bedesten, a multidomed market-building that became the nucleus of the famous Kapalı Çarşı, or Covered Bazaar, the largest covered market in existence, an Ottoman labyrinth that still attracts hordes of shoppers from all over the world.

A decade or so after the Conquest, Fatih walled off the seaward end of the peninsula so that he could build a palace secluded from the rest of the city. This palace, which came to be called Topkapı Sarayı, was the principal residence of the Ottomans sultans until 1856, when the royal family moved into the new palace of Dolmabahçe on the European shore of the Bosphorus. Thenceforth, Topkapı Sarayı was for the most part abandoned, until early in the Turkish Republic Atatürk ordered that it too be converted into a museum. I managed to gain entrance to

the Harem before it was restored and open to the public, and when I wandered through its abandoned rooms, I could feel the presence of the women and eunuchs who had spent their lives sequestered there at the pleasure of the Ottoman sultans, who referred to their labyrinthian palace as the House of Felicity.

Within two decades after the Conquest, Fatih completed work on a great mosque complex in the centre of the city. Known as Fatih Camii, the Mosque of the Conqueror, it was the centre of a vast *külliye*, or complex of religious and philanthropic institutions, the largest of its kind ever founded in the Ottoman Empire. The mosque was destroyed by an earthquake in 1766, and five years later it was replaced by another mosque built to a totally different design. Most of the other buildings of the complex survive in their original form, the most impressive being the eight great *medrese*.

Several of Fatih's viziers followed his example, building mosque complexes of their own, as did succeeding sultans. Each of these mosques became the centre of its surrounding neighbourhood, together developing into the new Muslim city of Istanbul.

Fatih also repopulated the city, which had greatly declined in numbers during the decades preceding the Conquest, as the Greeks fled the doomed Byzantine capital. Fatih brought in Christian Greeks and Armenians as well as Muslim Turks from both the Asian and European regions of the empire, housing them in the abandoned quarters of the city. His son and successor Beyazıt II (r. 1481–1512) welcomed Jews who had been expelled from Spain in 1492 by Ferdinand and Isabella, and resettled them in Istanbul and other cities of the Ottoman Empire. The Jewish refugees in Istanbul were housed along the shore of the Golden Horn as well as across the Horn in Galata, where Beyazıt also resettled Moors who had been expelled from Spain.

Each of the minority groups formed a separate *millet*, or nation, headed by its own religious leader. Thus the Greeks were headed by the Greek Orthodox Patriarch of Constantinople, the Armenians by the Patriarch of the Gregorian Orthodox Church, and the Jews by the Chief Rabbi. The Greek Orthodox Patriarchate is now in the Fener quarter on the Golden Horn, the Armenian Patriarchate is in Kumkapı on the Marmara. The Chief Rabbinate is in the heights above Galata, an area originally known as Pera and later as Beyoğlu, which became the nucleus of the new city that in late Ottoman times developed along the hills above the European shore of the lower Bosphorus.

During the years 1501–1506, Beyazıt II built an imperial mosque complex known as the Beyazidiye in the centre of the city. The Beyazidiye represents the beginning of the classical period of Ottoman architecture, which would last until the mid-seventeenth century, adorning Istanbul with most of its finest mosques and medreses.

The Ottoman Empire reached its peak during the reign of Süleyman the Magnificent (r. 1520–66), son and successor of Selim I. Süleyman personally led Ottoman armies in a dozen victorious campaigns in both southern Europe and western Asia, while his fleet ravaged the Mediterranean. He failed only in his attempts to take Vienna and Malta, which marked the high-water marks of Ottoman expansion in the West.

Süleyman was the greatest builder among the Ottoman sultans, erecting mosque complexes and other religious, civil and military structures throughout his empire. At the beginning of his reign, he built a huge palace on the Hippodrome for his intimate companion, the Grand Vizier İbrahim Paşa, whom he later executed. Süleyman's most notable foundation in Istanbul is the Süleymaniye, the imperial mosque complex erected in the 1550s by his chief architect Mimar Sinan. The mosque was the centre of a külliye that included half-a dozen medreses, a Kuran school, a hospital (with an insane asylum), an imaret, or refectory, a caravansaray, a primary school, a hamam, or public bath, and a street of shops, along with the *türbes*, or tombs, of Süleyman, his wife Roxelana, and Sinan, the architect of the Süleymaniye.

Sinan continued as chief of the imperial architects through the reign of Süleyman's son Selim II (r. 1566–74) and on, into the reign of his grandson Murat III (r. 1574–95). On the south wall of the garden around Sinan's tomb, there is a long inscription by Sinan's friend, the poet Mustafa Sa'i, who credits him with a total of 321 structures, erected throughout the Balkans, present-day Turkey, and the Middle East, of which 84 still remain standing in Istanbul alone, including 42 mosques. Sinan ranks with the leading architects of the European Renaissance, and he surpasses all of them in the enormous number of his constructions.

The earliest of Sinan's large mosques in Istanbul is Şehzade Camii, built by Süleyman in 1548 in memory of his eldest son, Prince Ahmet, who had died at the age of 21 five years earlier. The finest of Sinan's grand vizierial mosques are Rüstem Pasha Camii, built in 1561 in Eminönü on the Golden Horn, and Sokollu Mehmet Pasha Camii, erected in 1572 below the Hippodrome, both of them noted for their superb Iznik tiles.

The classical style of Ottoman architecture continued on into the sixteenth century under those who succeeded Sinan as Chief of the Imperial Architects. The most famous of the later classical mosques is Sultan Ahmet

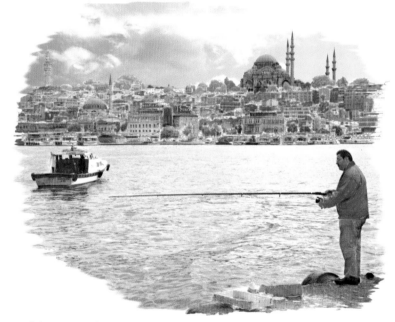

A fisherman on the Golden Horn near the Galata Bridge. On the skyline are two landmarks of the city: Süleymaniye Mosque (see pages 12, 36–37) and, on the left, the Beyazıt Fire Tower (also known as the Serasker Tower) in the grounds of the Istanbul University (page 38).

I Camii, better known to tourists as the Blue Mosque, which stands some 500 m southwest of Haghia Sophia. The mosque was founded by Sultan Ahmet I and built in the years 1609–1617 by Mehmet Ağa, Chief of the Imperial Architects.

The last of the imperial foundations in the classical style is Yeni Cami, the New Mosque, which dominates the Eminönü end of the Galata Bridge. This was built in 1663 by the architect Mustafa Ağa for the Valide Sultan (Queen Mother) Turhan Hadice, mother of Mehmet IV.

The market of the Yeni Cami complex is the handsome L-shaped building beside the mosque. It is called Mısır Çarşısı, or the Egyptian Market, because it was once the Istanbul outlet for imports from Cairo. It is better known in English as the Spice Bazaar, for it was once famous for the spices and medicinal herbs, which are still sold, there, along with a wide variety for other things.

The area around Yeni Cami has been the main market quarter of the city for more than two thousand years, and

The richly carved mimber of the Sokullu Mehmet Paşa mosque in Sultanahmet is crowned with a conical cap of sumptuous Iznik tiles. The mosque was built in 1571–2 by Sinan for the Grand Vizier for whom it is commonly named. It is, however, officially named after Sokullu Mehmet's wife, Esmahan Sultan, grand-daughter of Süleyman the Magnificent, who was 40 years her husband's junior.

when I stroll through its narrow streets, I feel that I am in touch with both Ottoman Istanbul and Byzantine Constantinople, for many of the things that are on sale here have not changed since time immemorial, such as the bronze cauldrons available on the Street of the Cauldron-Makers, which are mentioned by the seventeenth-century chronicler Evliya Çelebi.

Many of the market buildings in and around Eminönü are old Ottoman *hans*, or inner city caravansarais. There are a number of these caravansaries in and around the Covered Bazaar, the most picturesque being the Büyük Valide Hanı and the Zincirili Han.

The baroque style in art and architecture was introduced to Istanbul from France in the first half of the eighteenth century. The earliest baroque mosque is Nuruosmaniye Camii, completed in 1755 by Sultan Osman III. The most attractive example of the Turkish baroque style is Laleli Camii, the Tulip Mosque, built in 1763 for Sultan Mustafa III by the architect Mehmet Tahir Ağa.

Mahmut II began the *Tanzimat*, or Turkish reform movement, which was signed into Ottoman law in 1839 under his son and successor Abdül Mecit. Seven years later, Abdül Mecit commissioned the Armenian architect Karabet Balyan and his son Nikoğos to built a new palace at Dolmabahçe on the European shore of the lower Bosphorus. The Sultan and his household moved into the new palace a decade later, abandoning Topkapı Sarayı, which thenceforth was used to house the women of departed sultans until it was officially closed in 1909, after Abdül Hamit II was deposed by the Young Turks, the army officers who took control of the Ottoman Empire during its last years. Other imperial palaces were

The Four Seasons Hotel building is a masterly conversion of Turkey's first purpose-built prison. The Sultanahmet prison, completed in 1919 in the First National architectural style (see page 94), much in vogue at that time, was in continuous use in its original role until 1969. Work on its preparation for a very different clientele was begun in 1994.

Soğukçeşme Sokağı—the street of the
cold fountain—is squeezed between the
outer walls of Topkapı Palace and Haghia
Sophia. Its late 18th-century Ottoman style
wooden houses have been renovated by the
Turkish Touring and Automobile Club as
guesthouses for tourists.

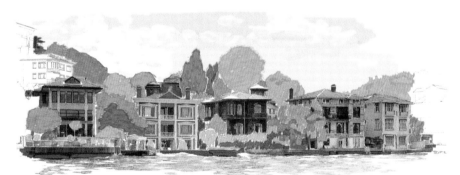

built along the Bosphorus in the third quarter of the nineteenth century including Yıldız, on the European shore, and Beylerbey and Küçüksu on the Asian side.

A number of foreign architects worked in Istanbul during the reign of Abdül Hamit II. Among them was the Italian Raimondo d'Aronco, who served as the Sultan's chief architect in the years 1893–1903. D'Aronco's extant buildings include the Şale Köşk at Yıldız Palace, the complex of Şeyh Zafer in Beşiktaş, and the Military Medical School at Haydarpaşa.

The reform movement also produced the first Ottoman institution of higher learning, the *Darürülfunun*, which registered its first students in 1869. The Darürülfunun was reorganised along western lines in 1900, and after the establishment of the Turkish Republic in 1923, it became the University of Istanbul, which is now housed in the old Ottoman Ministry of War on Beyazıt Square.

The reform movement allowed foreign schools to open in Istanbul, most notably the American Robert College, founded in 1863 on the Bosphorus above Rumeli Hisarı, and the French Galatasaray Lycée, established in 1868 in Beyoğlu. Robert College has since 1971 been the Turkish University of the Bosphorus, while Galatasaray now includes a university as well as a secondary school. These developments were part of a tremendous expansion of higher education under the Turkish Republic, which in the past half century has seen the number of universities increase from three to ninety-one, the realisation of Atatürk's vision of transforming Turkey into a modern secular nation. His reforms included the introduction of the Latin alphabet, the Gregorian calendar and western style clothing.

When the Turkish Republic was founded in 1923, Ankara became the capital. Thus for the first time in sixteen centuries, Istanbul was no longer the capital of a world empire. But it continues to be by far the most populous city in the country, the focus of modern Turkey's economic and cultural life, more vibrant and exciting today than it has been in living memory. The population of the city in 1924, a year after the creation of the Turkish Republic, was 1,165,866, of which about 700,000 were Muslim Turks, 300,000 Greeks, 80,000 Armenians and 70,000 Jews. The population in 1950 was only slightly over a million, less than it had been in 1924, but since then it has been increasing rapidly as rural Turks began moving into Istanbul

Yalıs on the Asian shore of the Bosphorus. Yalıs are summer residences, originally owned by a rich elite, and situated along the banks of the Bosphorus (the word yalı also means shore). Of the hundreds that lined the Bosphorus in the 18th century, few remain today and many of these are sadly decayed.

and the other large cities in search of work. The population of Istanbul was 4,433,000 in 1980, by which time twenty-five new municipalities had been added to the city, increasing its area by a factor of four. Most estimates today put the number at 12,000,000 or more, some thirty percent of whom live on the Asian side of the city, whose urban area has now spread out along both shores of the Marmara and far up the Bosphorus to within sight of the Black Sea. Despite the urban sprawl, the shores of the Bosphorus are still graced by picturesque old *yalı*, or waterfront mansions, particularly on the Asian shore, where each of the villages clusters around its *iskele*, or ferry-landing, some of which are gems of late Ottoman architecture.

Most of the new residents of Istanbul have been impoverished Anatolians who moved into illegally-constructed dwellings known as *gecekondu*, meaning 'built by night', or into once-fashionable residential neighbourhoods of the Greek, Armenian and Jewish minorities, turning them into slums. Most of the elegant old Ottoman wooden houses in the city were torn down in the process, some of them surviving only in the Bosphorus villages or as boutique hotels in the old city, such as the Ayasofya Pansiyonları on the street behind Haghia Sophia. The Ayasofya Pansiyonları was the creation of the late Çelik Gülersoy, who, as head of the Turkish Touring and Automobile Club in the late 1980s, began converting a number of late Ottoman palaces and mansion into

hotels, restaurants, cafés and crafts markets. Two of the wealthiest families in Turkey, the Koç and Sabanci, have transformed other Ottoman buildings into museums, as well as founding the first private universities in Turkey. A rather different conversion is the transformation by the Eczacıbaşı family of a warehouse, formerly used by the Istanbul Port Authority, into the highly praised Istanbul Museum of Modern Art. The Turkish government, on both the municipal and national level, has also initiated civic renewal and restoration projects in Istanbul, creating parks along the Golden Horn and the Bosphorus and restoring Byzantine and Ottoman monuments that had suffered neglect and decay. Many of the subsidiary buildings of the imperial mosques have now been converted to new functions, as at the Süleymaniye, where one of the medreses houses an important research library; the primary school is a children's library; the hospital serves as a maternity clinic; and the *imaret* is a restaurant specialising in Ottoman cuisine.

Zoning laws have prohibited the erection of overly large or tall new structures in old Istanbul, so the first modern shopping malls and high-rise commercial buildings have risen in the new districts outside the Theodosian walls and beyond Beyoğlu along the European shore of the Bosphorus, as well as in the suburbs on the Asian

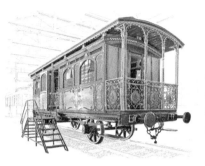

The railway coach in which Sultan Abdül Aziz travelled to Europe in June–July 1867—the first and last time that a ruler of the Ottoman Empire travelled abroad on an official visit—exhibited in the wonderful Rahmi M. Koç museum in Hasköy.

side of the city. Bagdat Caddesi, the main thoroughfare on the Asian side of the city, is now referred to, though with some hyperbole, as the Fifth Avenue of modern Istanbul.

During recent years modern highways were built in and around Istanbul, along with a metro system that extends along the lower European shore of the Golden Horn and through the old city out beyond the Theodosian walls, linking up the new suburbs with the historic inner city. New high-speed ferries now operate on the Bosphorus and the Marmara, taking commuters back and forth between the European and Asian sides of the city, which are also connected by older-style ferries that transport more than a million people a day between the continents.

The European and Asian sides of the city were linked on 27 October 1973, the fiftieth anniversary of the Turkish Republic, when the first Bosphorus Bridge, from Ortaköy to Beylerbeyi, was dedicated. A second span, the Mehmet Fatih Bridge, was completed farther up the Bosphorus in the summer of 1988, crossing the strait at its narrowest point, between Anadolu Hisarı, the Fortress of Asia, built in 1394 by Beyazıt I, and Rumeli Hisarı, the Castle of Europe, erected in 1452 by Fatih in preparation for his siege of Constantinople. According to Herodotus, this is where the Persian King Darius crossed the Bosphorus on a bridge of boats in 512 BCE. This was the first mention of Byzantium in history, 2,500 years before the opening of the Mehmet Fatih Bridge.

Such is the ancient city of Byzantium—Constantinople-Istanbul, now midway through the twenty-seventh century of its tumultuous existence. As Petrus Gyllius noted more than four and a half centuries ago, after describing the antiquities of the ancient imperial city standing astride the continents on the lower Bosphorus: 'It seems to me that while other cities are mortal, this one will endure while there are men on earth.'

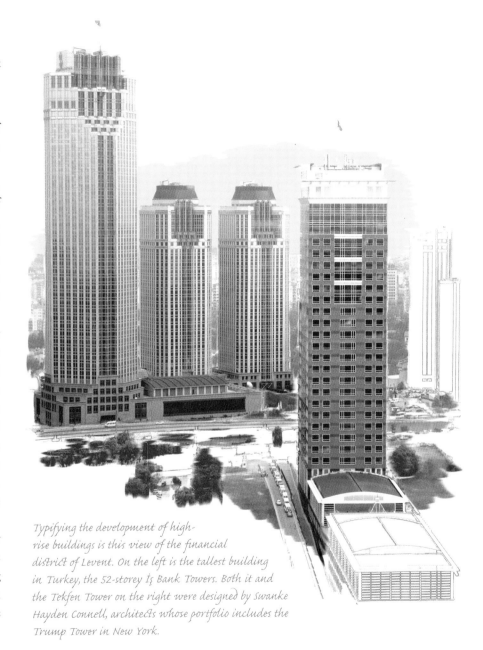

Typifying the development of high-rise buildings is this view of the financial district of Levent. On the left is the tallest building in Turkey, the 52-storey İş Bank Towers. Both it and the Tekfen Tower on the right were designed by Swanke Hayden Connell, architects whose portfolio includes the Trump Tower in New York.

The Historic Heart of Istanbul

The historic heart of Istanbul is at the apex of the Constantinopolitan peninsula, on the First Hill above the confluence of the Bosphorus and the Golden Horn. The most prominent historical monuments there are Topkapı Sarayı, Haghia Sophia and Sultan Ahmet I Camii, the famous Blue Mosque. With its graceful cascade of domes and semidomes and its six towering minarets, the Blue Mosque rivals Haghia Sophia in its grandeur, the two of them together with the pavilions of Topkapı Sarayı giving an imperial aspect to the skyline of the old city.

Other important monuments on the First Hill include the Archaeological Museum, the Basilica Cistern, the Mosque of Sokollu Mehmet Pasha, the remains of the Hippodrome, and the Palace of İbrahim Paşa, which houses the Museum of Turkish and Islamic Art.

Two of the most interesting of Istanbul's many museums—the Archeological Museum, and the Museum of Turkish Tiles—are arrayed beside the palace. The latter is housed in Çinili Köşk, the oldest extant structure of Topkapı Sarayı, built in 1472 as an outer pavilion. Among other important sites on the First Hill are the magnificent Basilica Cistern and the remains of the ancient Hippodrome, once the centre of civic activity in Constantinople.

Some of Istanbul's oldest and most interesting *mahalles*, or neighbourhoods, can be seen by strolling around the periphery of the peninsula, along the Golden Horn, the Theodosian Walls and the Marmara, with excursions into the interior of the city. Most of these quarters are named for mosques, some of them converted Byzantine churches, and other historic monuments that have for centuries been civic centres in the cultural mosaic of the old city.

The Zeyrek quarter is named for Zeyrek Camii, the former Byzantine church of the Pantocrator, whose three domes crown a ridge above the Golden Horn. The quarter known as Yedikule takes its name from the fortress of Yedikule, the Castle of the Seven Towers, which is built up against the Theodosian Walls near the Marmara shore, a structure partly Byzantine and partly Ottoman. The Fatih quarter, at the centre of the peninsula, is named for the great mosque complex of Mehmet the Conqueror, built on the site of the Byzantine church of the Holy Apostles. These have been landmarks of the city both as Byzantine Constantinople and Ottoman Istanbul.

The tuğra of Süleyman I over the Imperial Gate of Topkapı Palace. The tuğra is a uniquely Turkish concept, a monogram in highly formalised artistic calligraphy. A translation is: 'Süleyman Shah, son of ruler Selim Shah, ever victorious'.

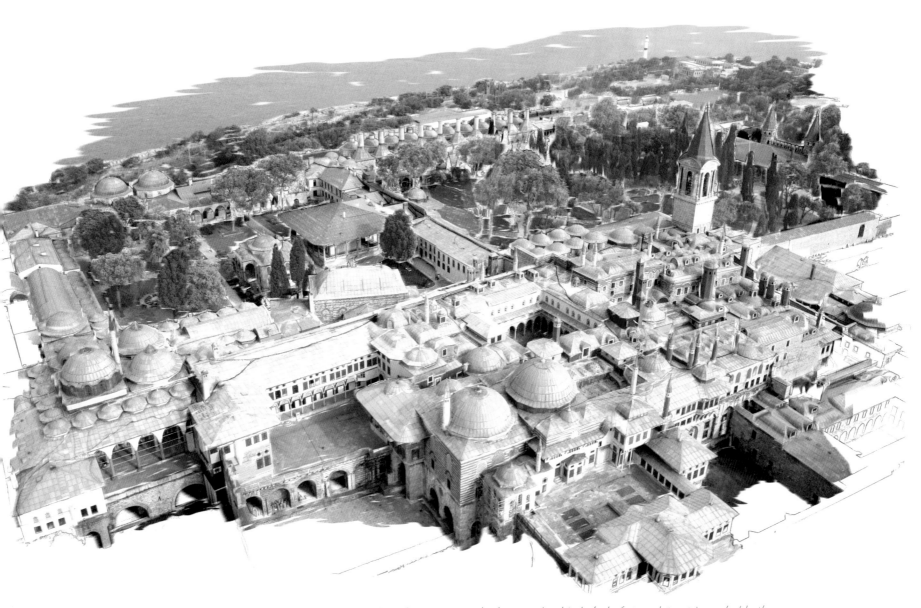

In this view from the northwest of the Topkapı Palace, the Harem is in the foreground. Behind, the leafy Second Court is marked by the tower of the Divan, or Council Chamber, and in the centre is the Gate of Felicity which is the entrance to the Third Court, the private domain of the Sultan. To its left is the overhanging roof of the Throne Room in which foreign ambassadors were received on their arrival.

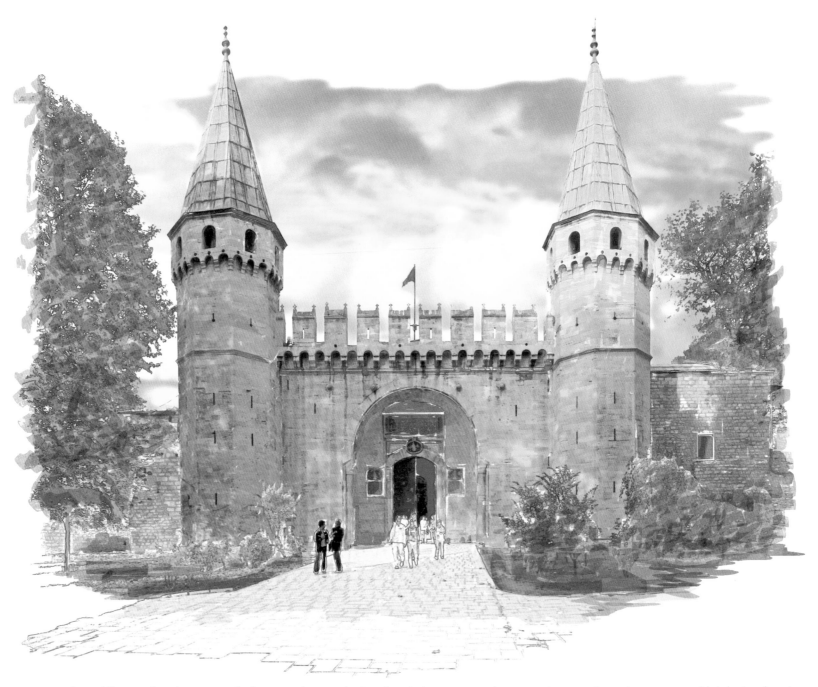

The Middle Gate of Topkapı Sarayı, also known as the Gate of Salutations, is the entrance to the Inner Palace. Its octagonal towers were added during the reign of Süleyman the Magnificent (1520–66). One of the rooms inside used to house the chief executioner—a post held by the principal gardener of the Palace.

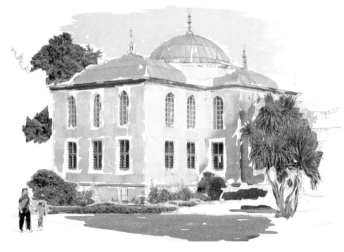

The elegant marble Library of Ahmet III stands by itself in the centre of the Third Court of the palace. It was built in 1719, the first year of the Tulip period, and was the only important building added to the Palace in Ahmet III's reign.

This elaborately painted and gilded fountain graces the façade below the main entrance to the library.

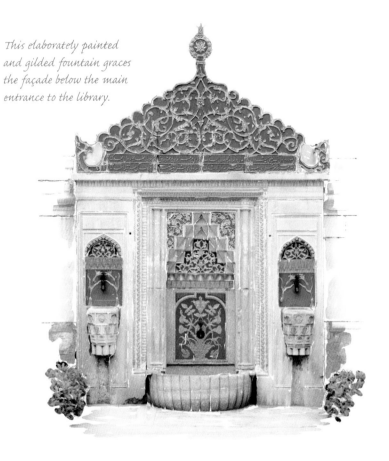

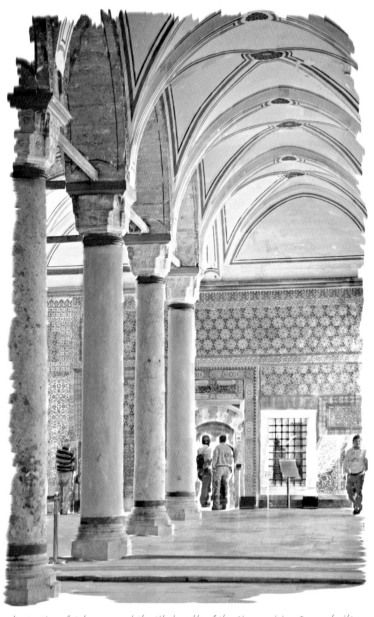

The Portico of Columns and the tiled walls of the Circumcision Room, built for Sultan Ibrahim in 1641 to commemorate the circumcision rites of his first son, the future Mehmet IV, opens onto the charming Marble Terrace. For 200 years, all Ottoman princes were circumcised in this room. The tiles date from several periods, their designs and colours representing the best of Iznik work.

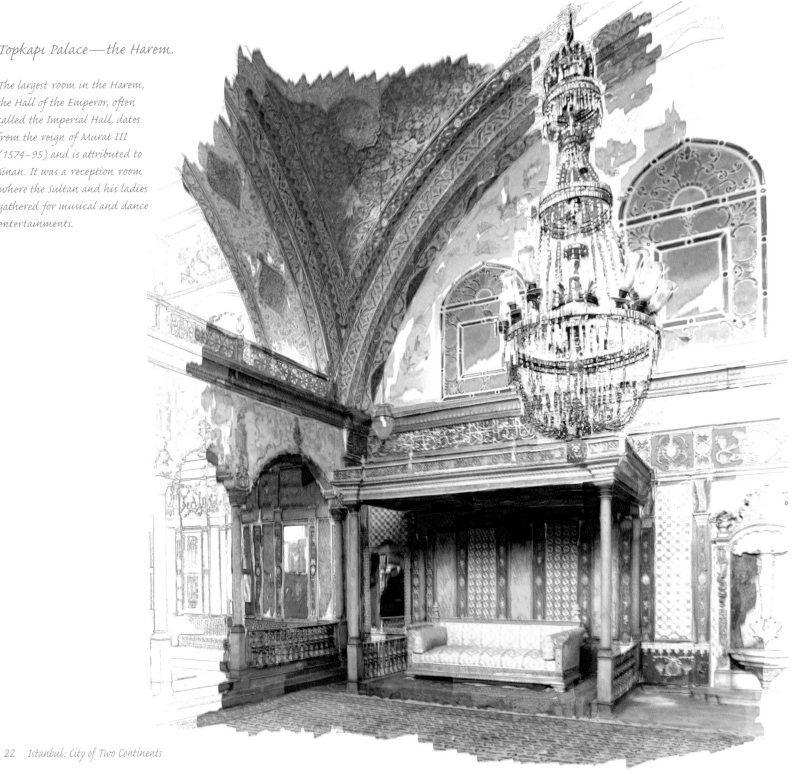

Topkapı Palace—the Harem.

The largest room in the Harem, the Hall of the Emperor, often called the Imperial Hall, dates from the reign of Murat III (1574–95) and is attributed to Sinan. It was a reception room where the Sultan and his ladies gathered for musical and dance entertainments.

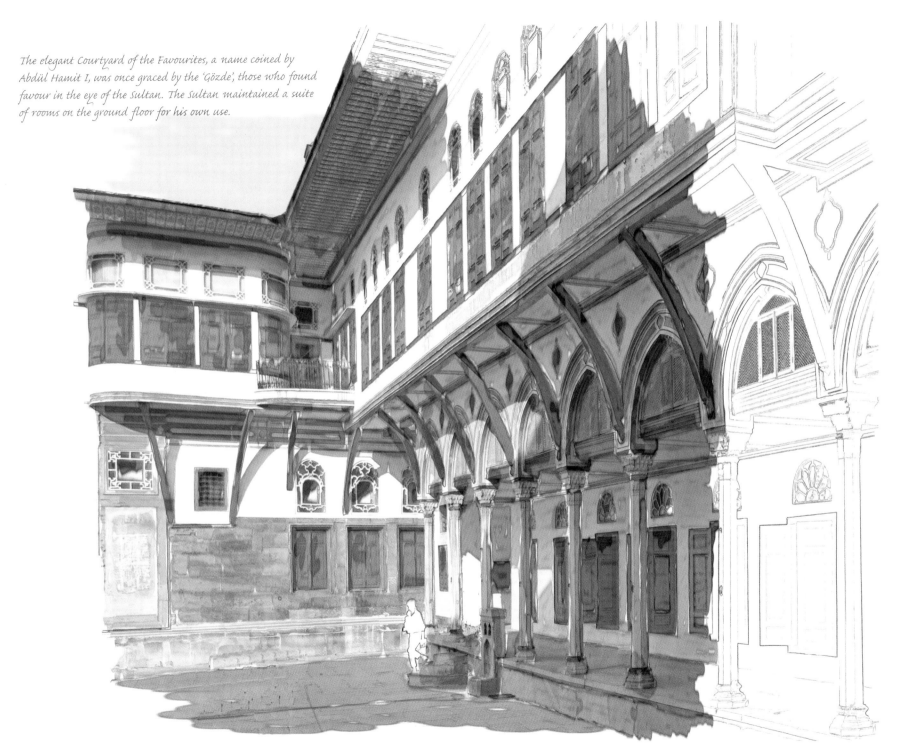

The elegant Courtyard of the Favourites, a name coined by Abdül Hamit I, was once graced by the 'Gözde', those who found favour in the eye of the Sultan. The Sultan maintained a suite of rooms on the ground floor for his own use.

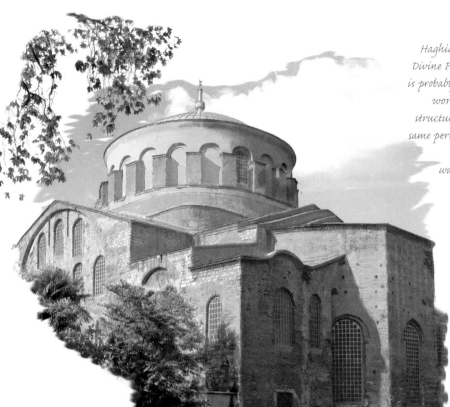

Haghia Eirene—the church of the Divine Peace—was erected on what is probably the oldest site of Christian worship in the city. The present structure dates from 532 to 537, the same period as Haghia Sophia, except for the main dome which was rebuilt in the 8th century. After the Conquest, it was included in the Topkapı complex as an armoury. Today it is mainly used for cultural meetings and concerts, taking advantage of its excellent acoustics.

The best known of the collection in the Archaeological Museum is the beautifully carved Alexander Sarcophagus, so called because the reliefs depict Alexander the Great in battle and hunting scenes. In the fragment shown here, Alexander attacks a Persian soldier.

One of the few museums in the city designed and built as such, the Archeological Museum was opened in 1891 under the directorship of Osman Hamdi Bey, discoverer of the fabulous sarcophagi in the royal necropolis at Sidon, in Syria, now housed in the museum. With over 50,000 recorded objects, the museum has one of the world's richest collections of classical and pre-classical artefacts.

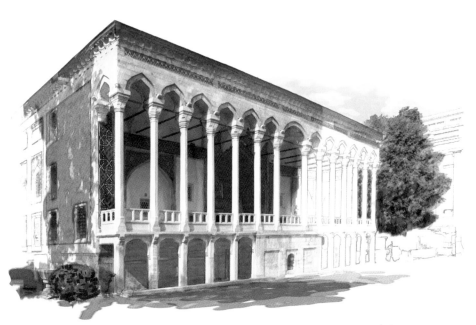

The Persian style Tiled Pavilion—the Çinili Köşk—with its elegant arcaded entrance portico is one of the oldest secular structures in Istanbul. It was built in 1472 as a summer pavilion from which Mehmet II is variously reported to have watched the martial equestrian sport of Cirit, or, more poetically, to have used for evening pleasures. It first became a storehouse for antiquities in 1874 and then a museum housing a superb collection of ceramics in the 1950's.

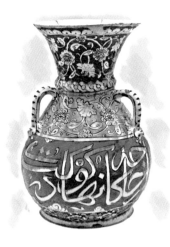

This late 18th-century mosque lamp, exhibited in the Çinili Köşk, is from the Kütahya potteries which, although active from as early as the 1500s, came into their own early in the 18th century as Iznik ceramic and tile production declined.

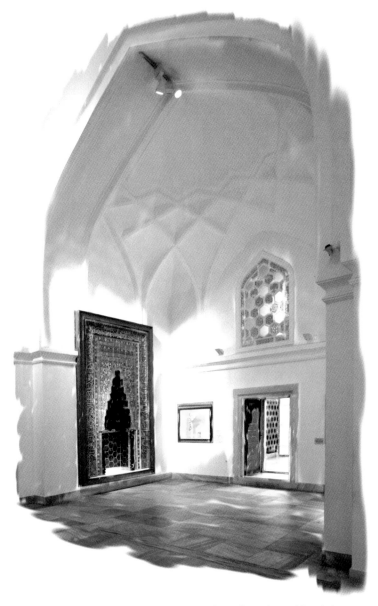

In the soaring central salon of the Tiled Pavilion, the richly tiled mihrab from the mosque of İbrahim Bey at Karaman, in southern Turkey, provides a stunning centrepiece. This is one of the finest works from the Iznik period.

One of the truly great buildings of the world, Haghia Sophia—the Holy Wisdom—was the cathedral of Byzantine Constantinople for over 1,000 years and then, for nearly five centuries, as Aya Sofya Camii, was one of the most important mosques of Istanbul. It was closed in 1934 for restoration before being opened as a museum.

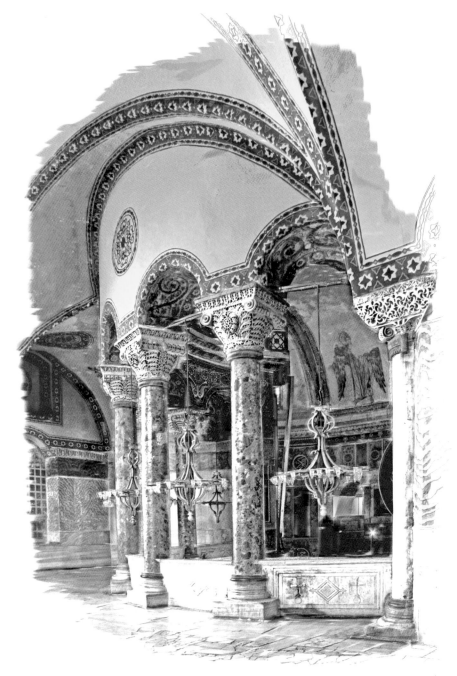

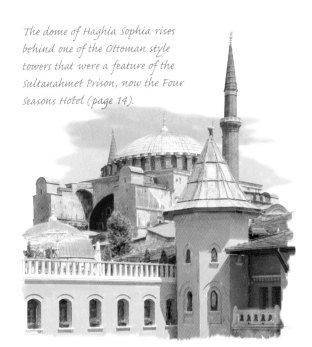

The dome of Haghia Sophia rises behind one of the Ottoman style towers that were a feature of the Sultanahmet Prison, now the Four Seasons Hotel (page 14).

The Upper Gallery of Haghia Sophia underwent major restoration between 1847 and 1849 under the direction of architect Gaspare Fossati. The capitals of the columns shown here are unique, decorated with deeply cut acanthus and palm leaves and the imperial monograms of Emperor Justinian and his wife, Theodora.

The charming Hamam of Roxelana, on the east side of the park between Haghia Sophia and the Blue Mosque, was commissioned by Süleyman the Magnificent in the name of his former concubine and then wife, Haseki Hürrem, better known as Roxelana (the Russian). Finished in 1556, it is considered the finest of 32 hamams designed by Sinan. A double hamam, with one end for men and the other for women, it was in operation until 1910. After restoration, it was opened as a carpet shop operated by the Ministry of Culture.

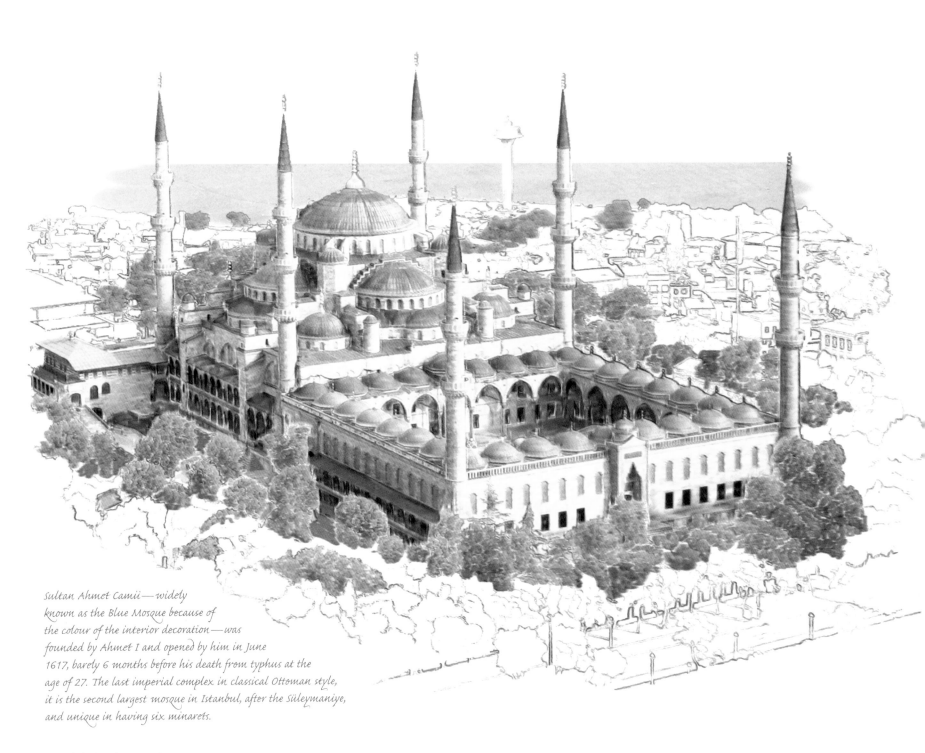

Sultan Ahmet Camii—widely
known as the Blue Mosque because of
the colour of the interior decoration—was
founded by Ahmet I and opened by him in June
1617, barely 6 months before his death from typhus at the
age of 27. The last imperial complex in classical Ottoman style,
it is the second largest mosque in Istanbul, after the Süleymaniye,
and unique in having six minarets.

The Hippodrome—Sultan Ahmet Square.

The gazebo-like fountain in the northern end of the old Hippodrome was a gift of German Emperor Wilhelm II to Abdül Hamit II as a token of friendship to the Sultan and his people on the occasion of the Kaiser's state visit in 1898. It was built in Germany, shipped in parts, reassembled on its current site and inaugurated on 27 January 1901, Wilhelm II's birthday.

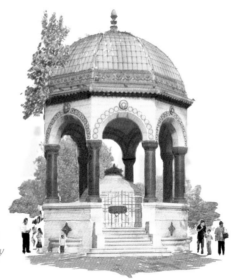

The Egyptian Obelisk and the Land Registry. Only the upper two-thirds of the otherwise remarkably well-preserved Obelisk, which dates from about 1500 BCE, survived the journey from Alexandria. It was erected here in AD390, mounted on a marble base with sculptured reliefs featuring Emperor Theodosius the Great. The extension to the Ottoman Land Registry, on the left, designed in Ottoman revivalist style by Vedat Tek Bey (whose Post Office (page 33) was being built at the same time), was opened in 1908.

A balcony of the Palace of İbrahim Paşa overlooks the Hippodrome, a park that in Roman times was the site of an enormous arena. The palace, a grand private residence completed c. 1520 was in part demolished to make way for the Land Registry: what remains is a rare surviving example of 16th-century Ottoman domestic architecture. It now houses the fine Museum of Turkish and Islamic Arts.

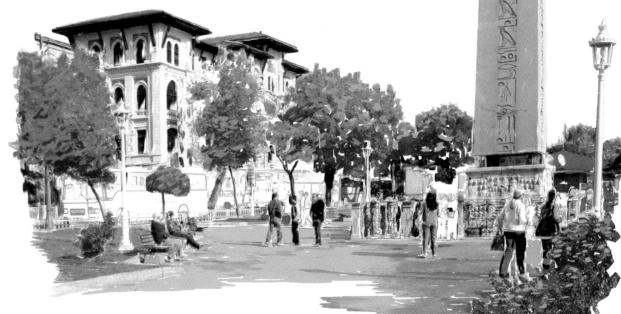

Nargile smokers in the Çorlulu Ali Paşa Courtyard. The nargile, which originated in India where it is known as Hookah or Hukka, has become popular especially in the Arab world.

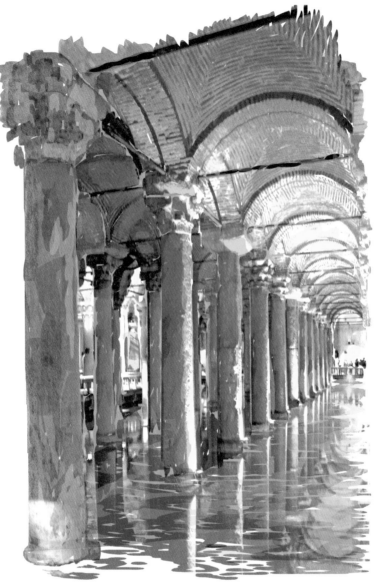

The Milion, or Miliarium Aureum—the Golden Milestone—was a monumental Byzantine archway. It disappeared after the Conquest: this remaining fragment was excavated in 1952. The original archway was surmounted by a sculpture of Constantine (r. 324–37) and his mother, Helena. At that time road distances to all parts of the Byzantine Empire were measured from this point.

With a plan area twice that of Haghia Sophia, the Basilica Cistern is by far the largest of some 60 underground water storage tanks in the city dating from Roman times. Built by Emperor Justinian (527–565) to store excess water from the aqueduct during the winter to ensure a summer supply, it was a major source for the long-disappeared Great Palace and the area around Haghia Sophia into Ottoman times. It was opened to the public in 1987 after years of restoration.

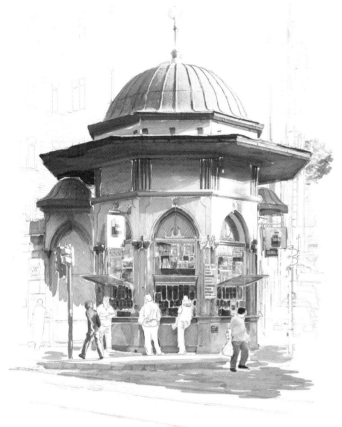

The Muradiye Sebil on Hüdavendigar Caddesi, Sirkeci, dates from the late 16th century although it was renovated in 1876 when it was named for Sultan Murat V, and took on its neo-Gothic features. It is today a kiosk. Murat, an alcoholic who came to power after the death of his uncle Abdul Aziz, reigned for only 3 months, before himself being deposed on grounds of insanity.

In former times, the Sublime Porte led to the offices of the Grand Vizier where, from the mid 17th century, the main business of the Ottoman Empire was transacted. Thus it came to stand for the Ottoman Government itself, and foreign ambassadors were said to be 'Ambassadors to the Sublime Porte'. This present rococo style ornamental gateway, now the entrance to the Istanbul provincial government, the Vilayet, was built by Abdül Mecit I in 1840.

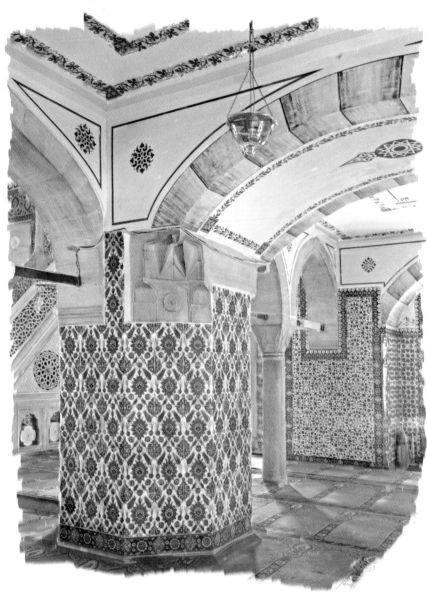

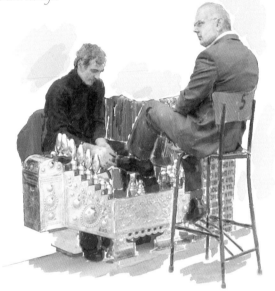

This shoeshine with his elaborate stand is one of many to be found plying their trade beside Yeni Cami—the 'new mosque'—which today is something of a misnomer for a building started over four centuries ago.

The Egyptian Market (Mısır Çarşısı), so called because of the origin of most of its wares (and also known as the Spice Bazaar for the produce for which it was famed), is a covered arcade of 86 vaulted shops. Its colourful displays are of heaped spices, dried vegetables and fruits, nuts, perfumeries and herbal remedies and also, today, a variety of less exotic wares.

Floral Iznik tiles of the highest quality sheath the walls and the porch façade up to the arches of the beautiful mosque built for Rüstem Paşa by Sinan. It was completed in 1562 but the current interior décor dates from the 17th century. The mosque is built on a terrace over shops, the proceeds from which went to maintain the foundation.

Recently refurbished and opened as the World Park Hotel, the former Fourth Vakıf Hanı is a masterpiece of architect Kemalettin Bey. The Ottoman revivalist building was started in 1911, but construction was interrupted by World War I during which it was used as the French general headquarters under the name of 'Caserne Victor'. It was completed in 1926.

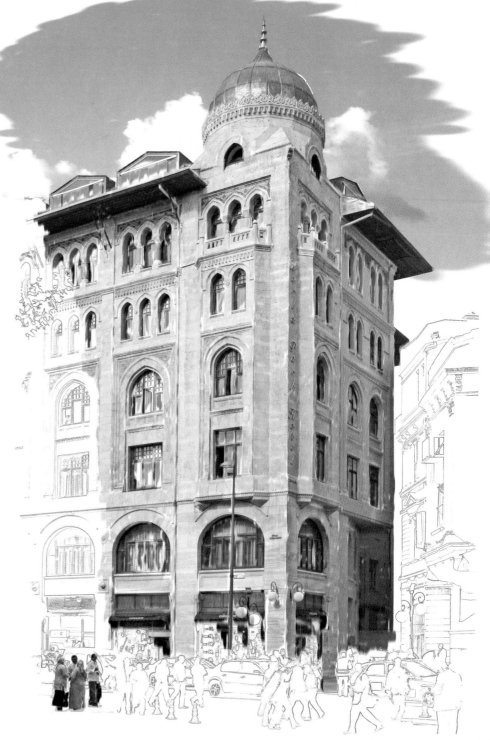

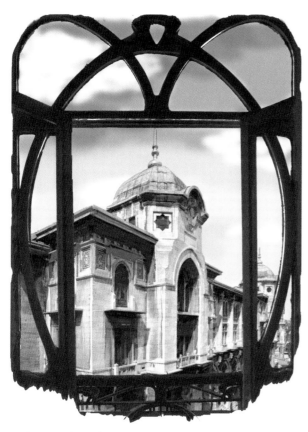

Architect Vedat Tek Bey's first and major work, the striking Post Office building in Sirkeci, finished in 1909, is seen through a window of the Flora Han. Although now dilapidated, the appropriately named han—its façades are extensively decorated with a rose motif—is one of Istanbul's finest examples of the Art Nouveau architecture that was popular from about 1900 to 1930.

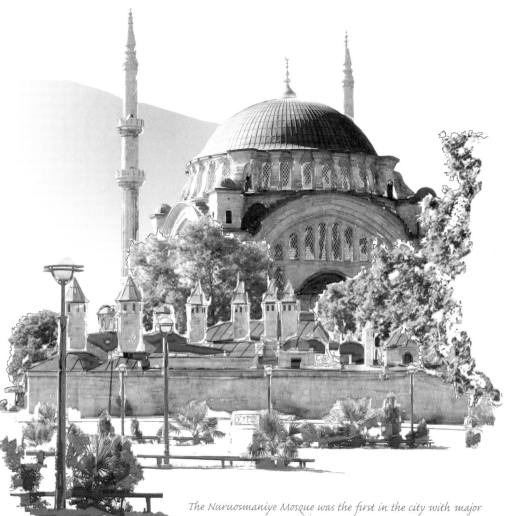

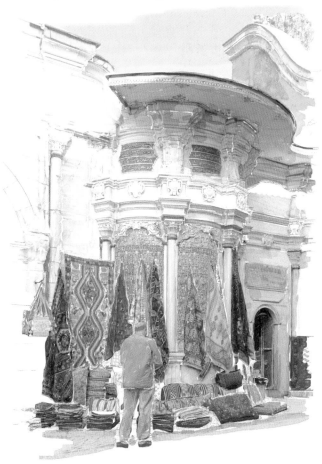

A carpet seller plies his trade opposite the Nuruosmaniye gate to Kapalı Çarşı, the Covered Bazaar or Grand Bazaar. The gate is the most impressive of all the market entrances, splendidly decorated with the imperial coat of arms which incorporates the Sultan's tuğra.

The Nuruosmaniye Mosque was the first in the city with major elements of the baroque style that was being introduced from Western Europe at that time. Started in 1748 by Mahmut I, it was finished in 1755 by his brother and successor Osman III from whom it takes its name, which means 'the mosque of the sacred light of Osman'. It was designed by a Greek master-builder, Simeon Kalfa.

Grand Bazaar

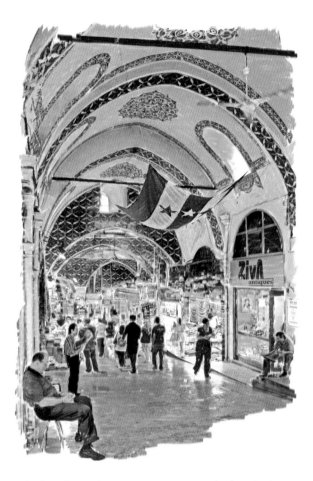

The attractive pink-walled Zincirli (or Chain) Han in the northeast corner of the Bazaar is a typical 18th-century han, a two-storey arcaded structure built round a central courtyard. Today, it houses carpet merchants and jewellers.

The famed Grand Bazaar is a vast network of vaulted arcades with over 3,000 stores under one roof. Traditionally shopkeepers clustered together according to the kinds of goods or services on offer—as they still do —and this is reflected in many of the old arcade names such as Fez-Makers Street, Jewellers Street and Gate of the Engravers.

The Sülumaniye: the largest of Sinan's works.

Incontestably one of the most important Ottoman building in Europe, this enormous complex—a contemporary of Michaelangelo's St. Peter's in Rome—demonstrates the architect's great technical skill and artistic flair.

Süleymaniye Mosque: the southwest entrance to the courtyard.

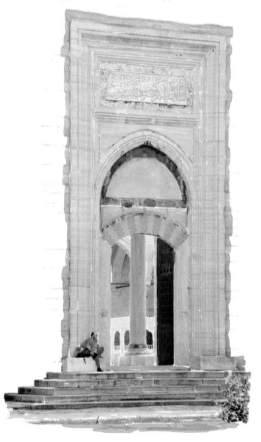

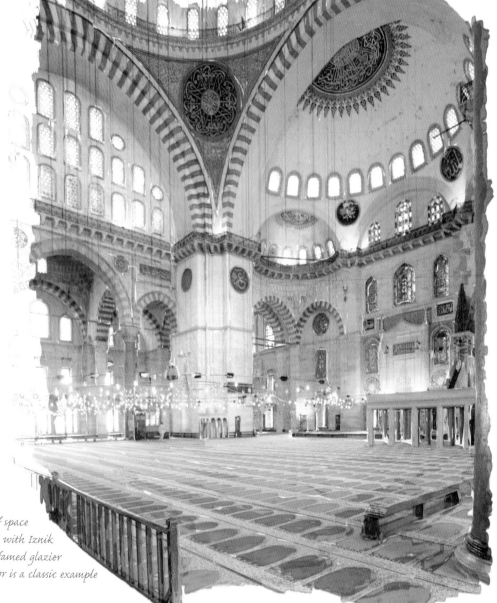

On entering the mosque, the immediate impression is of space and a soaring dome borne by four great piers. Decorated with Iznik tiles and stunning stained glass windows—some by a famed glazier known as Sarhoş ('the Drunkard') İbrahim—the interior is a classic example of Ottoman religious art.

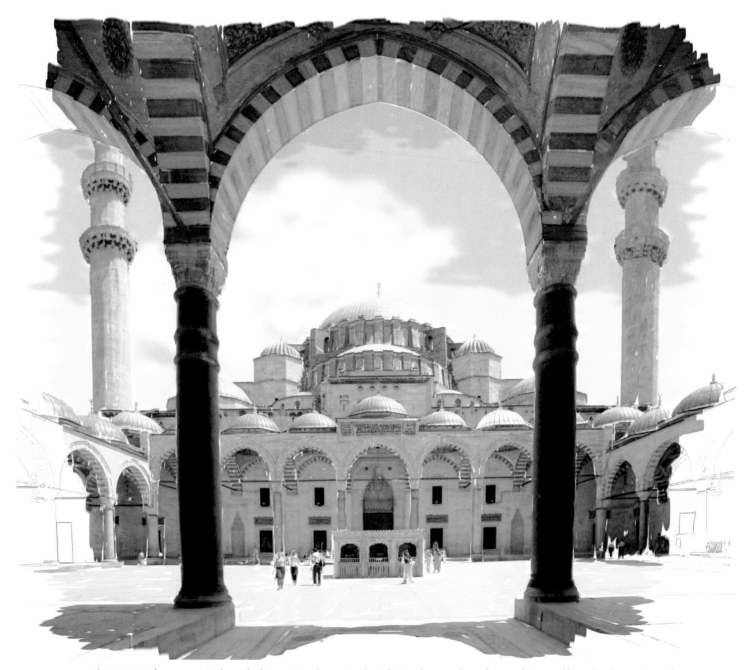

The entry to the mosque is through this porticoed courtyard with 24 columns of porphyry, white marble and red granite with handsome stalactite capitals. At the corners rise four slender minarets, with a total of 10 balconies, said to signify that Süleyman was the 4th Sultan in Istanbul and the 10th of the Ottoman Dynasty.

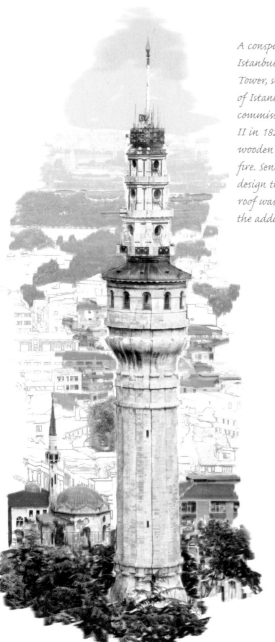

A conspicuous feature of the Istanbul skyline, the Beyazıt Fire Tower, stands in the grounds of Istanbul University. It was commissioned by Sultan Mahmud II in 1828 to replace an earlier wooden one that was destroyed by fire. Senekerim Balyan's original design that included a conical roof was modified in 1849 with the addition of three storeys.

Ablutions in the courtyard of the Beyazıt Mosque. The fountain that Muslims use for ritually washing their face, hands and feet, symbolically purifying their bodies before entering the prayer hall, is typically set in the centre of the courtyard of the mosque.

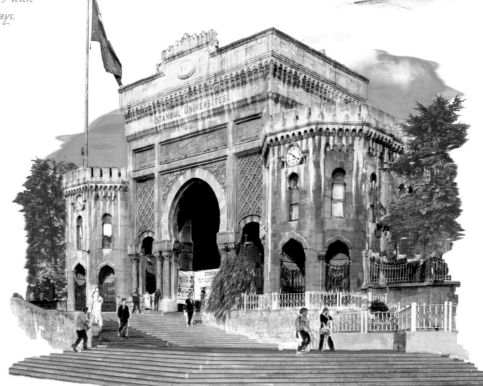

The Moorish-style gate to the main campus of the University of Istanbul dominates Beyazıt Square, a pedestrian area that was the first of its kind in Turkey. Founded in 1900 and reorganised in its present form in 1933, the University now offers courses in 17 faculties to nearly 70,000 undergraduate and postgraduate students on five campuses, making it the largest higher educational institution in the country.

Ordu Caddesi

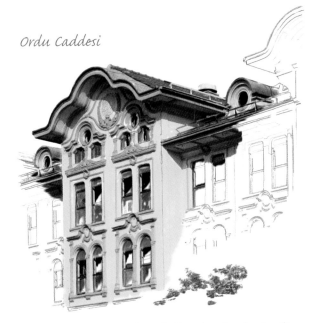

The Laleli Mosque complex, completed in 1763, was designed by Mehmet Tahir Ağa, considered the most original of the Turkish baroque architects. The lovely sebil with its bronze grillwork stands by the entrance to the terrace. In the türbe behind are the remains of Mustafa III, who died in 1774, and his son Selim III who was murdered by the Janissaries in 1807, following his attempts to reform the Ottoman armed forces.

The Merit Antique Hotel was built as housing for families rendered homeless in 1918 by disastrous fires. The design of architect Kemalettin Bey (page 94) with its bay windows and Ottoman baroque curved elements harmonised well with the adjoining Laleli Mosque. The complex was converted to a hotel, at that time run by Ramada, in the 1980s.

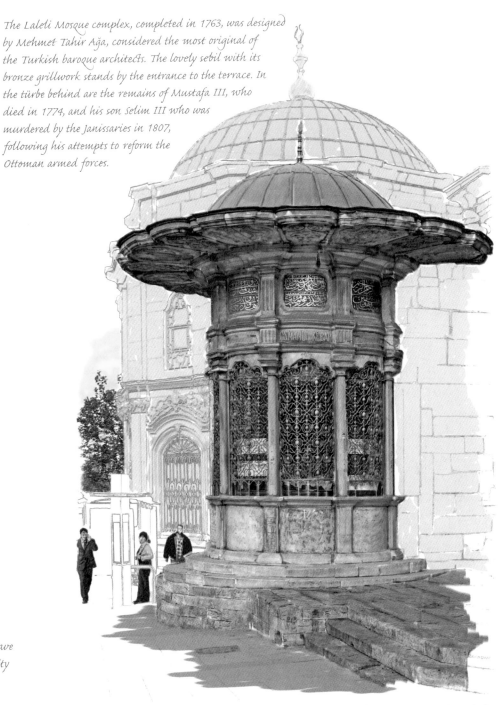

Remains of the 4th-century Forum of Theodosius are scattered along Ordu Caddesi below the Beyazıt mosque. The huge marble columns decorated with a motif resembling a peacock's tail were once part of a triumphal arch. Columns from the derelict forum have been reused all over the city including in the Basilica Cistern (page 30).

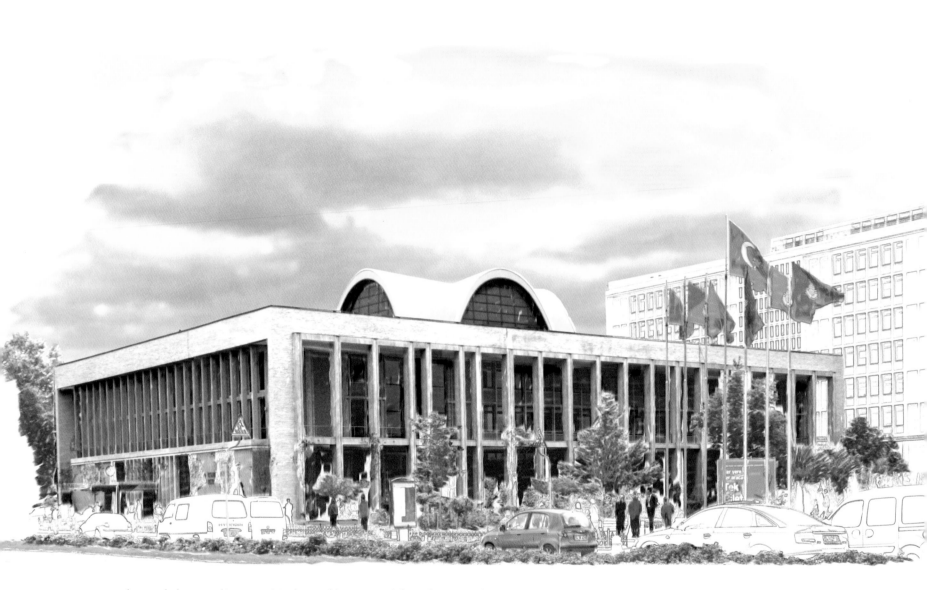

The Istanbul Metropolitan Municipality Building is one of the earliest examples of post-war international style architecture in Turkey. In Nevzat Erol's design, selected in a nation-wide competition, the dome pays homage to the Şehzade Mehmet Mosque that stands across the road. The smaller part of the 1953 complex, shown here, houses the mayor's office, council chambers and exhibition space and is used for ceremonial functions.

In the walled garden beside Sinan's first imperial mosque, the Şehzade Camii—the Prince's Mosque—completed in 1548, is the fine tomb of the eldest and favourite son of Süleyman the Magnificent, Prince Mehmet, who died of smallpox in 1543.

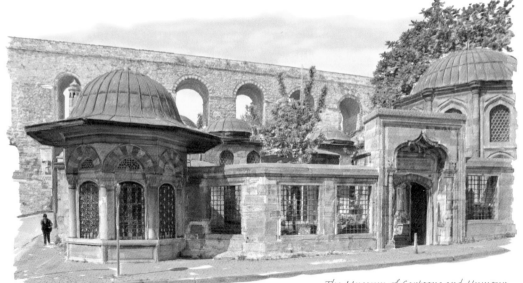

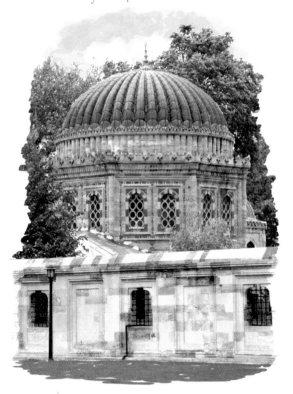

The Museum of Cartoons and Humour is a charming demonstration that humour is universal and that a good cartoon transcends the limitations of language. It is housed in the medrese founded in 1599 by Gazanfer Ağa, chief of the white eunuchs who, until Gazanfer's execution in 1603, dominated as guardians of the Topkapı. The museum, nestled against the Aqueduct of Valens, seen in the background, is just off Atatürk Boulevard.

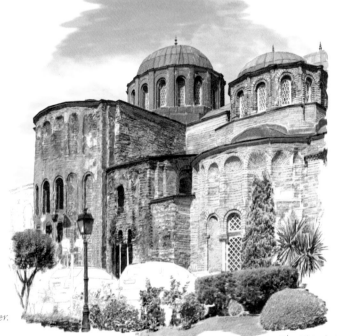

The Church of the Pantocrator is, after Haghia Sophia, the largest example of medieval Byzantine architecture surviving in Istanbul. It once comprised two churches, a chapel, and a now vanished monastery founded between 1120 and 1136. After the Conquest, a medrese was established in the complex that was later converted to a mosque and named Molla Zeyrek Camii for the medrese's first teacher.

St. Saviour in Chora—the Kariye Museum.

The Kariye Museum, which was originally the monastery church of St. Saviour in Chora ('in the country'), displays mosaics and frescoes considered the most important series of Byzantine paintings in the world. This view is of the rear of the church: the majority of the fabric dates from 1081 although the dome is Turkish. After serving as a mosque for over 400 years, it was opened as a museum in 1958.

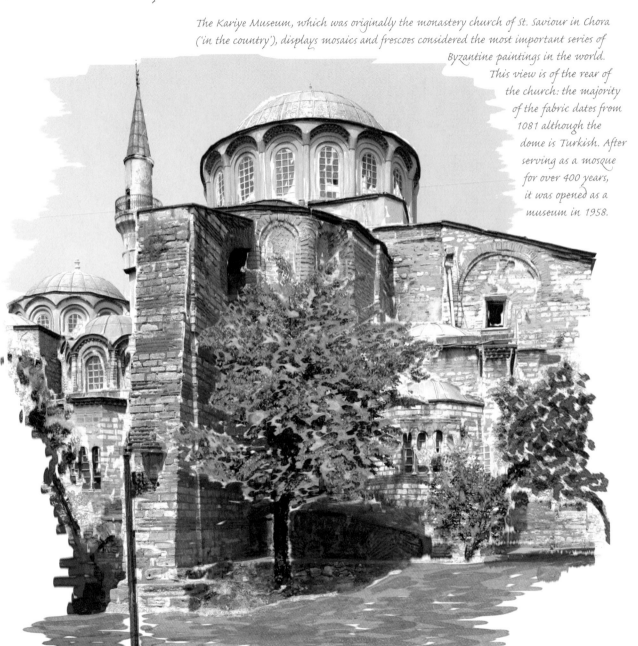

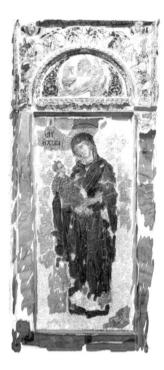

The framed mosaic of the Virgin and Child is one of a pair with that of Christ that flank the apse of the former monastery church. It once formed the right of a chancel screen, now missing, and had a gold background that has also been lost.

The former Byzantine Church of the Monastery of Theotokos Pammakaristos (the Joyous Mother of God) was founded in the twelfth century. It was converted into a mosque—Fethiye Camii, the Mosque of the Conquest—in 1591 and the main space continues to be used for Islamic prayer. A side-chapel, added to the church in the early 14th century, was decorated with fine mosaics.
These, together with the fabric, were restored to their pre-Ottoman state in the 1960's and the area is now open as a museum.

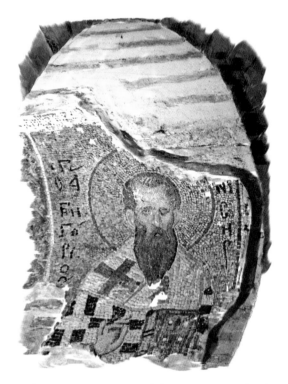

This mosaic on a cornice of the museum area depicts St. Gregory of Nyssa. A theologian and one of three brothers born in Cappadocia who became bishops in the time of the Emperor Valens (ruled 364–378), Gregory made several visits to Constantinople.

Fener. The old Greek quarter on the shore of the Golden Horn.

The handsome neo-gothic Church of St. Stephen, dedicated to the patron saint of Bulgaria, is made entirely of cast iron. Designed by the Armenian architect Hovsep Aznavour (1853–1935), it was erected in 1871 having been prefabricated in Vienna and shipped in sections down the Danube, across the Black Sea and along the Bosphorus to Fener.

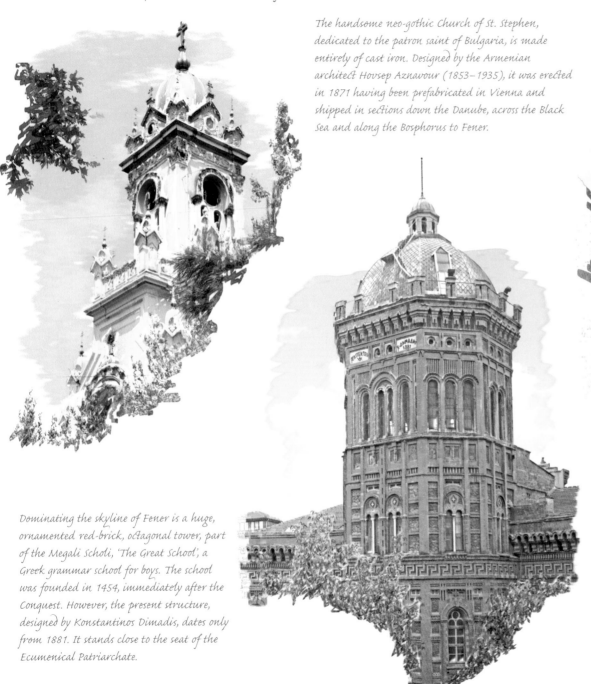

Of more historical than architectural significance, this tiny Byzantine church is commonly known as the Church of St. Mary of the Mongols. It is the only Byzantine church in Istanbul that has not, at some time, been in Ottoman hands, the right of the local Greeks to keep it having been granted in an imperial decree—still displayed at the church—by Mehmet II after the Conquest.

Dominating the skyline of Fener is a huge, ornamented red-brick, octagonal tower, part of the Megali Scholi, 'The Great School'; a Greek grammar school for boys. The school was founded in 1454, immediately after the Conquest. However, the present structure, designed by Konstantinos Dimadis, dates only from 1881. It stands close to the seat of the Ecumenical Patriarchate.

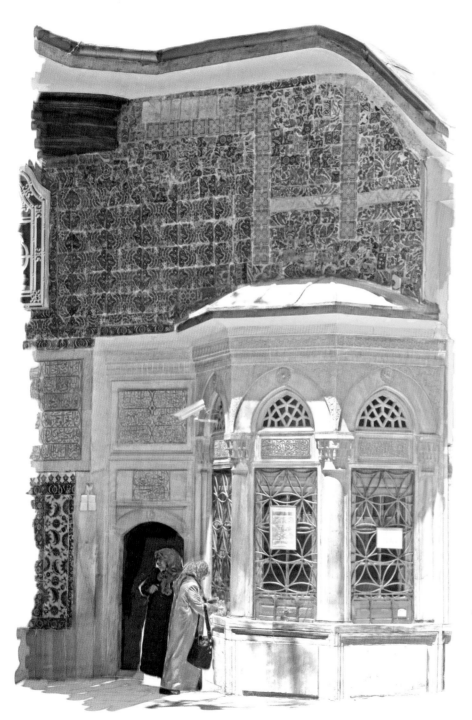

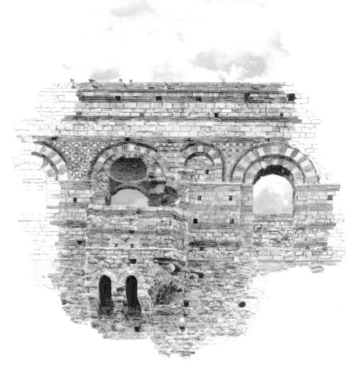

Tekfur Sarayı—the Palace of the Emperor—dates from the late 13th century. Today, the shell of this once fine annex to Blachernae Palace at the north end of the Theodosian Walls, is the most important surviving example of Byzantine secular architecture of the period. Some of the elaborate geometrical design that used to adorn the whole palace can be seen in this view of a balconied window in the east façade of the ruins.

Eyüp Sultan Mosque: the entrance to the tomb of Eyüp Ensari on the inner courtyard. Eyüp, companion and standard-bearer of the Prophet, was killed in the first Arab siege of Constantinople in 674–8 and buried outside the walls. Five years after Mehmet II took the city in 1453 he built a mosque, later levelled by an earthquake, at the site of Eyüp's tomb. The present complex was built on the site by Selim III in 1800. The tomb, covered with a wealth of Iznik tiles of various periods, is at the centre and is visited daily by hosts of supplicants.

Yedikule, the castle of the seven towers, is partly Byzantine and partly Ottoman. Four towers are part of the Theodosian Walls and three round towers were added by Mehmet the Conqueror around 1457/8 to form a fortress within the Walls in which to keep the state treasury. The view is of one of the later round towers (which once had conical roofs) and the buttresses on the thick curtain walls that link the towers.

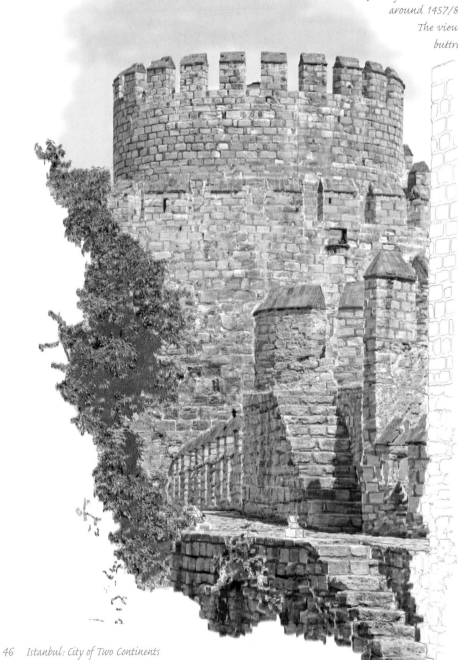

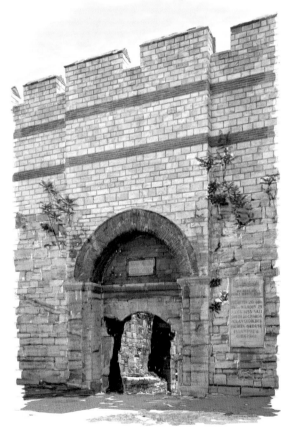

Edirne Kapı, also known as the Adrianople Gate, stands at the highest point of the historic city. It was here that Mehmet II, mounted on a mule and followed by 70–80,000 of his cheering troops, made his triumphal entry into the city on 29 May 1453, an event recorded on the plaque beside the gate.

The land walls essentially defined the western limit of Istanbul until the mid 20th century. This formidable 6.5-km (4-miles) long defensive system, running from the Sea of Marmara to the Golden Horn, was constructed by Emperor Theodosius II in the fifth century. It comprised 96 towers linked by an 11-m (36-ft) high curtain wall, running behind an outer rampart linking 96 smaller towers that alternate in position with those of the outer wall, and a broad moat. The sketch shows the Belgrade Gate (Belgrad Kapısı): the former moat in the foreground is now cultivated by market gardeners.

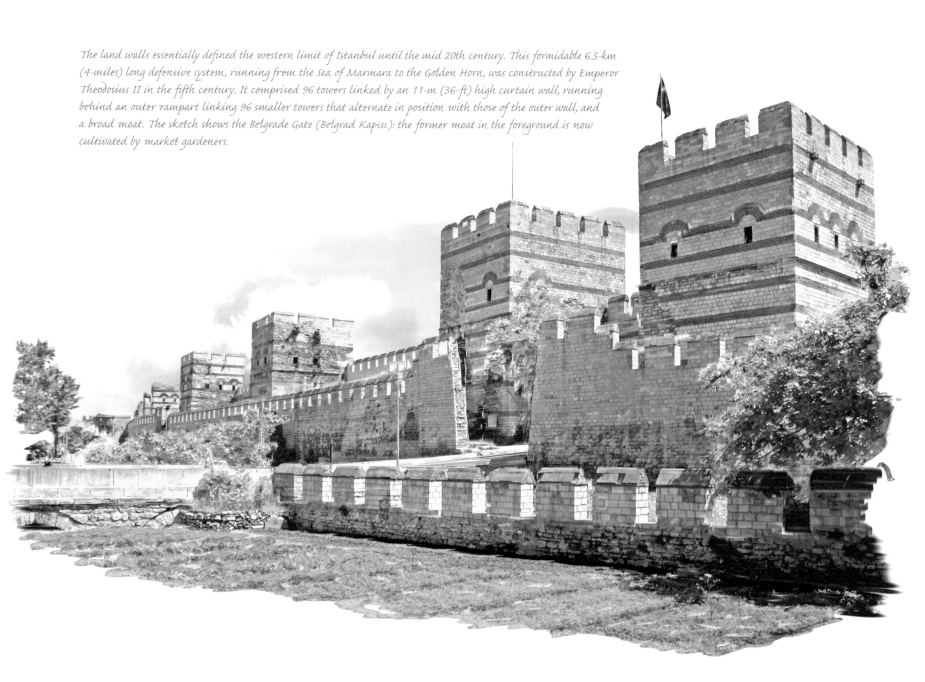

Across the Golden Horn: Beyoğlu and Beyond

The old Genoese town of Galata, the Latin Quarter of the city, is now part of the municipality of Beyoğlu, which comprises the region north of the Golden Horn along the lower European shore of the Bosphorus. The Galata Tower, built by the Genoese in 1348, is the most prominent landmark on the north shore; other notable monuments are Arap Camii, a church converted into a mosque for Moorish refugees; and a medieval postern in the old defensive walls known as Yanık Kapı, the Burnt Gate.

Beyoğlu began its development in the late Ottoman era when the European powers built embassies along the road that came to be called the Grand Rue de Pera, today's Istiklal Caddesi, now a pedestrian mall with a tramway. The lower end of the avenue is at Tünel, named for the funicular railway from Karaköy on the Golden Horn. Nearby is the Galata Mevlevihane, the lodge of the Mevlevi, famous in the West as the Whirling Dervishes.

The tram runs along Istiklal Caddesi from Tünel to Taksim Square, with a stop midway at Galatasaray Square, named for the famous lycée there. All of the old embassies are on or near Istiklal between Tünel and Galatasaray, along with three Roman Catholic churches. The section between Galatasaray and Taksim is the epicentre of Istanbul's hyperactive night life, with wall-to-wall restaurants, bars and cafés, many of them with deafening music both Turkish and western.

Cumhurriyet Caddesi leads from Taksim to the more modern districts of Harbiye, Şişli, Nisantaşı, Levent, Etiler and Maslak, the new financial centre of Istanbul, whose towers give a Manhattan-like aspect to the modern city developing above the European shore of the middle Bosphorus.

The old villages along the lower Bosphorus have now been amalgamated into the urban sprawl of Istanbul, particularly on the European side. The most prominent monument on the European shore of the lower Bosphorus is Dolmabahçe Sarayı, the principal residence of the Ottoman sultans from 1856 onwards, although Sultan Abdül Hamit II preferred the more secluded Yıldız Sarayı nearby. Both are now museums. The most beautiful stretch of the Bosphorus is at its narrowest point, between Rumeli Hisarı and Anadolu Hisarı, the Castles of Europe and Asia, particularly in spring, when judas trees blossom on the hillsides and nightingales serenade one another through the midnight hours.

The Galata Tower, built by the Genoese in 1348, is a feature of the skyline across the Golden Horn—and is the emblem of the Beyoğlu Council. The tower's observation deck provides a stunning vantage point from which to view the historic city.

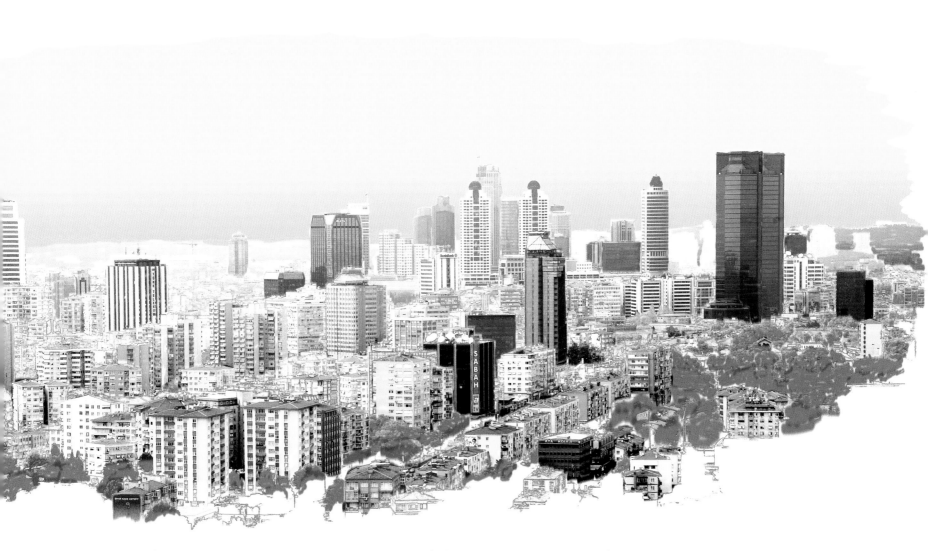

High rise developments in Şişli and Levent are rapidly giving the business and financial area a Manhattan-like appearance. The northward move of corporate headquarters and large commercial centres began in the 1970's, stimulated by the opening of the Bosphorus Bridge (1973) and related new motorways. Construction of the Fatih Sultan Mehmet Bridge, opened in 1988, has accelerated the transformation.

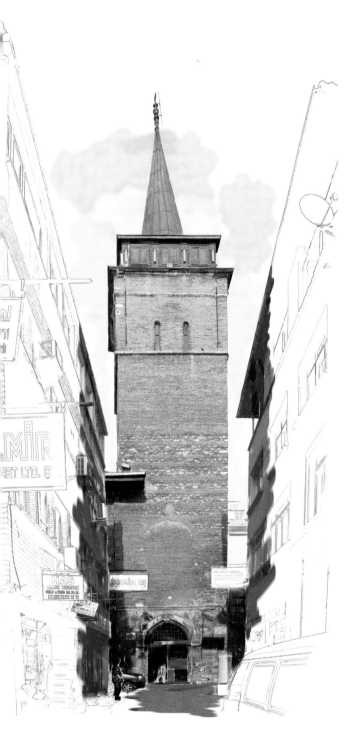

In the 14th century, the Genoese who had settled in Galata fortified their semi-independent colony. Above the only surviving portal in the remains of the wall, known as Yanık Kapı, the Burnt Gate, is this bronze coat of arms in which the Genoese cross of St. George is supported by escutcheons with the arms of the noble houses of d'Auria and de Merude.

Arap Camii was originally a church, built in the years 1323–37 by Dominican monks and dedicated to SS Paul and Dominic. It was converted into a mosque after the Conquest and in the 16th century, was given over to the colony of Moorish refugees who had settled in Galata after being expelled from Granada—hence its Turkish name, the Arabs' mosque.

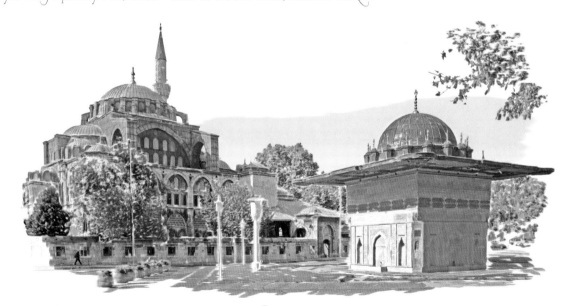

The Kılıç Ali Paşa mosque at Tophane, commissioned in 1580, was built on the shore of the Bosphorus, although it is now some way from the water due to reclamation. In this work late into his career, architect Sinan again took Haghia Sophia as his inspiration but incorporated Ottoman architectural elements. In the foreground is the spectacular Tophane fountain, its marble walls completely covered with floral designs typical of the Tulip Period (1728–32) in which it was built.

Bankalar Caddesi

The twin buildings used today by the Ottoman Bank Museum, a corporation of Garanti Bank, and the Istanbul branch of the Central Bank of the Republic of Turkey, were completed in 1892, to the design of Alexandre Vallaury, whose Archeological Museum (page 24) had just opened. His stunning neo-classical façade, shown here, is on Bankalar Caddesi—the most important axis of Galata—while the rear façade, looking over the Golden Horn, displays strong Ottoman elements.

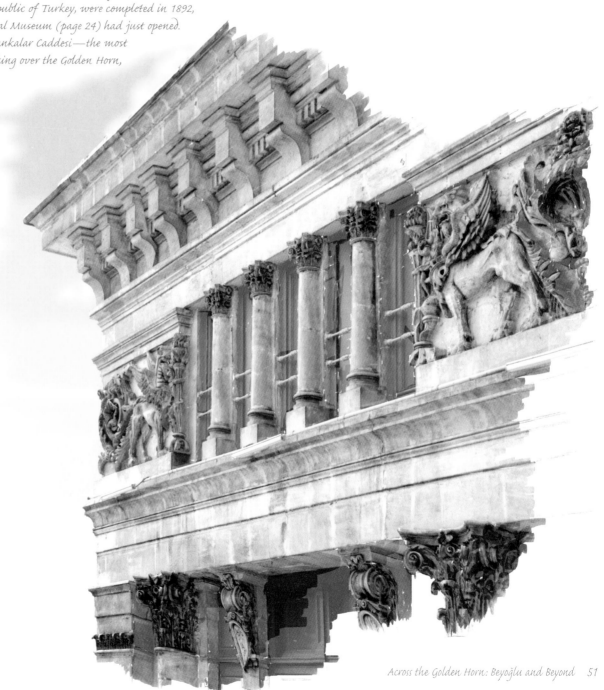

The Kamondo Stairs, off Bankalar Caddesi, are named for Abraham Kamondo, a banker who paid for their construction around 1870–80. Part staircase, part urban sculpture, they were immortalised in the early 1960s in a photograph by Henri Cartier Bresson. They were restored in 1985.

The Laleli (Tulip) fountain in Galata, designed by Raimondo D'Aronco in 1903–04, combines Art Nouveau and stylised Ottoman elements. The corner it once graced has been overwhelmed by local stores and after years of neglect, the fountain badly needs repair.

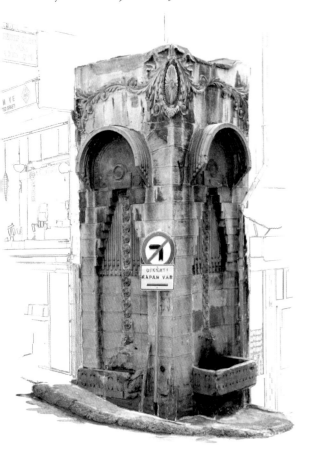

The Mevlevi, the most famous sect of the mystical Sufi branch of Islam, established a monastery in Galata about 1492. At its heart is an 18th-century wooden lodge with an octagonal dance floor on which groups of 15–16 Mevlevi regularly perform their ritual of ecstatic meditation that concludes with the protracted spinning which gives rise to their popular name—the Whirling Dervishes.

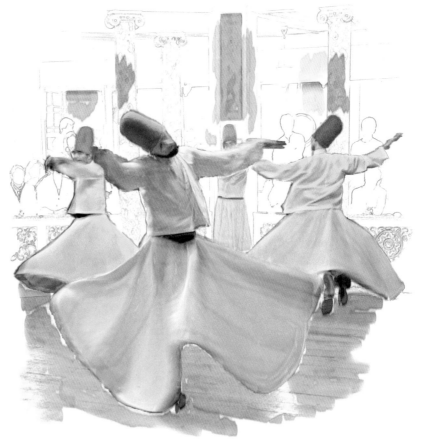

A house built in 1900 by Raimondo D'Aronco (see page 95) for Dutchman Jean Botter, couturier to the court of Abdül Hamit II, was the first Art Nouveau building in Pera and is one of the best known in Istanbul although now badly dilapidated. The sketch shows a detail of the doorway on Istiklal Caddesi.

The present St. Mary Draperis church on Istiklal Caddesi was built in 1904, replacing an earlier one destroyed in the Pera fire. This statue of the Virgin stands above the entrance gate in the façade of the Santa Maria Han.

St. Anthony of Padua, Istanbul's largest Catholic church, was built in 1913 on Istiklal Caddesi on the site of an earlier Franciscan church established in 1725. The Italian neo-gothic design is by Guilio Mongeri, who at the same time designed the arcaded apartments facing on to the courtyard of the church, built to generate income.

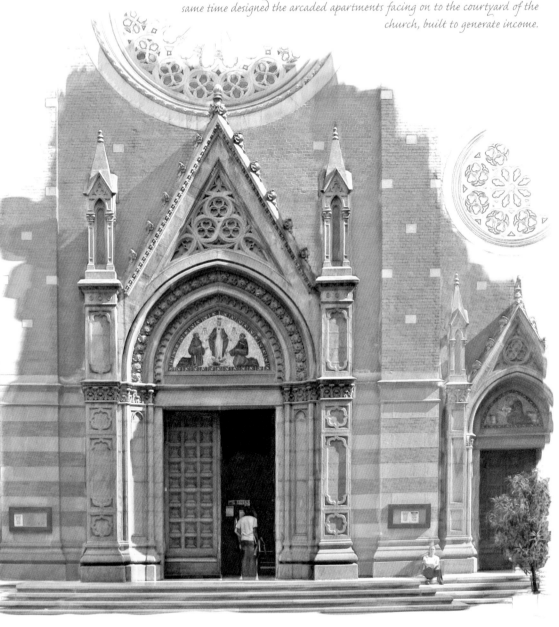

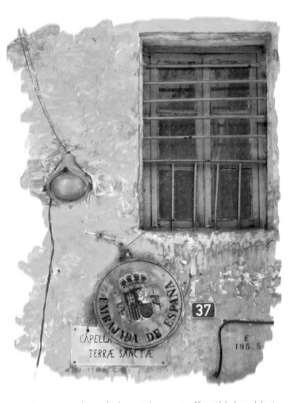

On Postacılar Sokak, a side street off Istiklal Caddesi, the site of the now defunct Spanish Embassy is still marked by a battered and faded plaque above the door of the embassy chapel that was founded in 1670: the present church dates from 1871.

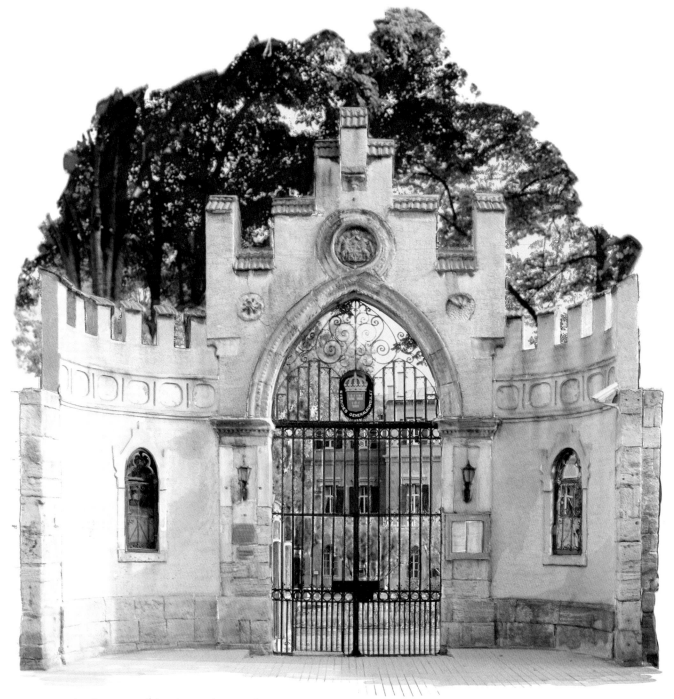

The elegant Swedish Palace—the Consulate General on Istiklal Caddesi—is Sweden's oldest state holding abroad. At the top of the fine gateway in the sketch are the arms of King Karl XIV Johan (reigned 1818–44), the colourful French-born founder of the Bernadotte Dynasty, who occupies the throne to this day.

This Coat of Arms, seen here in front of the Russian consulate, has historical connections with Istanbul. The double-headed eagle, symbolising the unity of Church and State, was the insignia of the late Byzantine Empire. It was adopted for the Imperial Coat of Arms by Ivan III after his marriage with the Byzantine princess Sophia Paleologina, and was restored, with minor changes, after the fall of the Soviet Union.

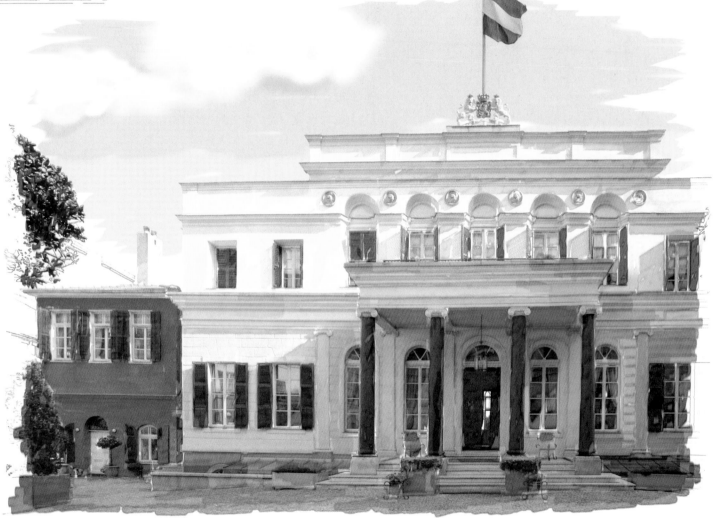

The Dutch consulate, the Palais de Hollande, was built in 1859 to the design of Italian architect Giovanni Barborini. It was part of the revival of the Grande rue de Péra, now Istiklal Caddesi, and replaced an earlier wooden structure destroyed in the fire of 1831. The building on the left served as the chancery from 1859 to 2000 when it became the home of the vice-Consul.

The graceful Salle de Fête in the Maison de France, built in 1847 by architect Pierre Laurécisque and now the Istanbul Residence of the French ambassador. France became the first European nation to establish diplomatic relations with the Ottoman Empire when François I sent an emissary to Süleyman the Magnificent in 1535 and was also the first to build an embassy in Pera.

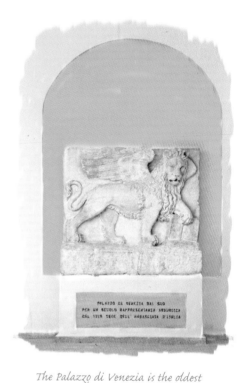

The Palazzo di Venezia is the oldest surviving embassy building in the city. Since it was built in 1695, it has passed from Venice to France to the Austro-Hungarian Empire (thus the reference to 'Asburgica' or Hapsburgs on this Venetian lion in the lovely Italian garden which surrounds it), and finally back to Italy in 1919. It is now the Istanbul residence of the Italian ambassador in Ankara.

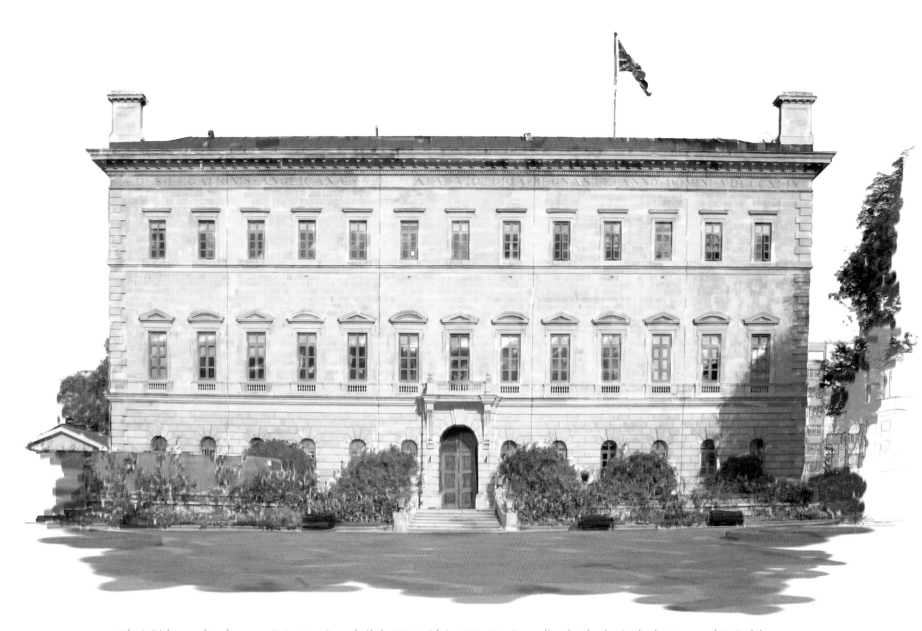

The British consulate, known as 'Pera House', was built by W.J. Smith in 1845–47 using earlier sketches by Sir Charles Barry, architect of the Houses of Parliament in London. It replaced a building destroyed by fire in 1831, was in turn damaged in the Pera fire of 1870 but restored 3 years later, and damaged again in a bomb attack in 2003. This view of the italianate palace is from the splendid gardens.

Galatasaray Square

Hot chestnuts sold on Istiklal Caddesi.

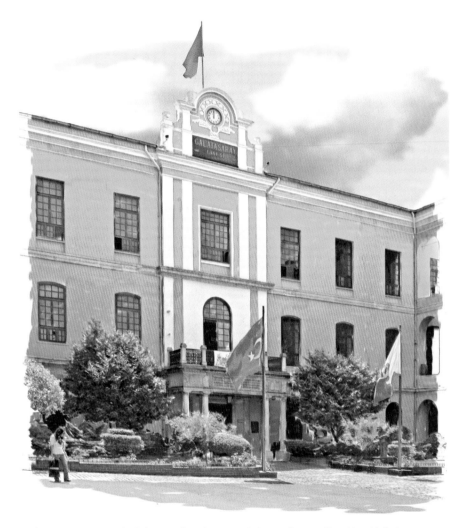

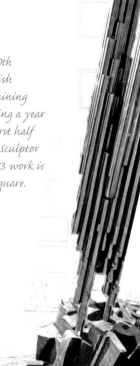

The Monument to the 50th Anniversary of the Turkish Republic comprises 50 shining steel rods, each symbolising a year of achievement in the first half century of the Republic. Sculptor Metimet Şadi Çalık's 1973 work is located on Galatasaray Square.

Galatasaray Lisesi, which has produced many of those who, in all walks of life, have shaped modern Turkey, is the oldest Turkish high school in Istanbul. It traces its history to 1481 and the establishment here by Beyazıt II of an off-shoot of the Topkapı Palace school: thus it is also referred to as the 'Sultani'. The current building dates from 1908.

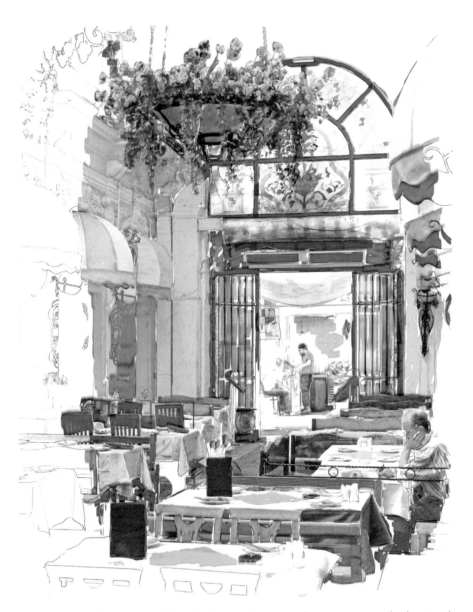

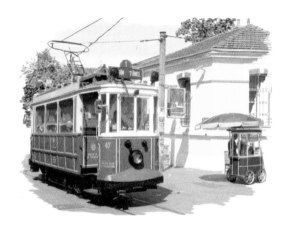

A Tünel-to-Taksim Square tram passes the Institut Français (which also houses the offices of the French Consul)—and a 'simit' vendor—on Istiklal Caddesi. The Consulate was originally a hospital for plague victims, built in 1719. The early 20th-century 'nostalgic' trams were returned to this 1.6-km (1-mile) route in 1990.

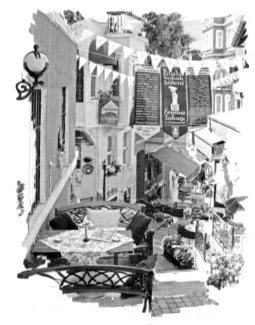

Çiçek Pasajı (Flower Arcade) was built as a shopping and apartment complex by a Greek banker, Zografos Efendi, and opened as the 'Cité de Péra' in 1876. In 1930 the Florists' Cooperative occupied it—thus its current name—and in the 1950's, it became an arcade full of meyhane (taverns). Refurbished in the late 1970s, it moved up-market.

A rehabilitation project in 2003 turned the old Cezayir Sokağı—a back alley of Galatasaray running parallel to Yeni Çarşı Caddesi—into a colourful pedestrian street. It was renamed Fransız Sokağı (French Street) to reflect the style of its new cafés and boutiques.

Bird-houses are often found on the exterior of mosques, typically of the baroque period, but they are also to be found on secular structures. This example is on the Taksim which gives the square its name.

An Istanbul Metro sign on Taksim Square, currently the southern terminus of the system.

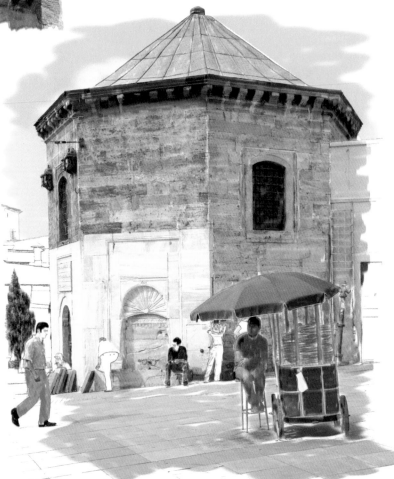

This Taksim or water distribution centre, was built in 1732 to collect water brought in by aqueduct from reservoirs in the Belgrade Forest some 20 km (12 miles) to the north. The vendor under the red umbrella, a familiar sight on the streets of Istanbul, is selling crisp rings of sesame-covered bread called simit.

Taksim Square was Istanbul's first public park and is the centre of the modern city. At one time it was the site of a large cemetery.

The Republic Monument dominates the west side of Taksim Square. On one side, it portrays Atatürk and other members of the nationalist movement during the War of Independence (see page 6) and on the other (seen here), Atatürk is with leaders of the Turkish Republic, created in 1923. The monument, erected in 1928, is by sculptor Pietro Canonica and architect Guilio Mongeri (page 94).

The coffee shop of the Marmara Hotel looks out onto Taksim Square. Coffee has a long history in Istanbul where the first coffee shop was opened in 1554—a century before they started to appear in the capitals of Western Europe.

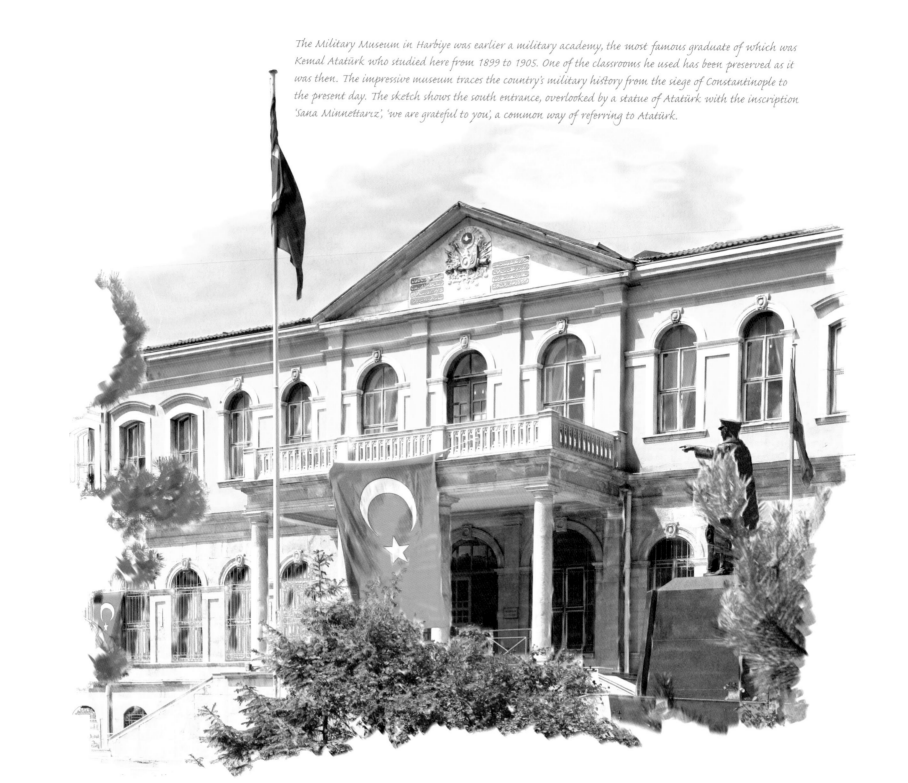

The Military Museum in Harbiye was earlier a military academy, the most famous graduate of which was Kemal Atatürk who studied here from 1899 to 1905. One of the classrooms he used has been preserved as it was then. The impressive museum traces the country's military history from the siege of Constantinople to the present day. The sketch shows the south entrance, overlooked by a statue of Atatürk with the inscription 'Sana Minnettarız', 'we are grateful to you', a common way of referring to Atatürk.

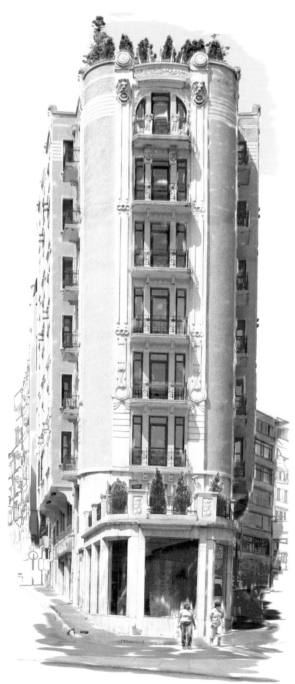

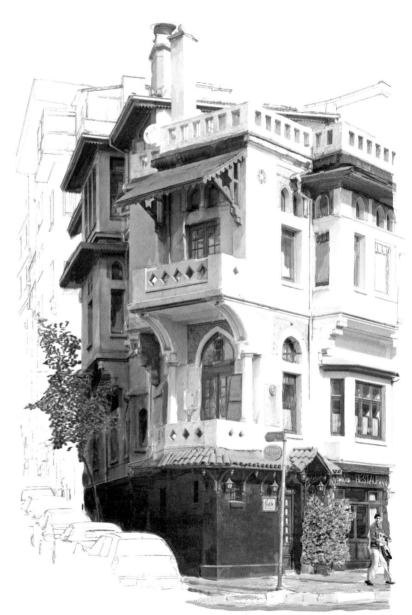

In 1913–14 architect Vedat Tek Bey built this house in Nişantaşı for himself. A combination of neo-Ottoman and Art Deco styles is apparent in this adaptation to a difficult sloping corner site. The protected building now has a restaurant on the ground floor and the first floor was opened as the stylish Zihni Bar in 2006.

Opposite the Military Museum, where Cumhuriyet Caddesi divides, the awkward corner has been turned into this striking Art Nouveau façade. Built as the Lucy apartment house in the early 1920's, it was later converted to bank offices.

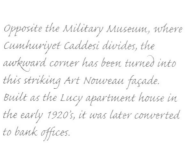

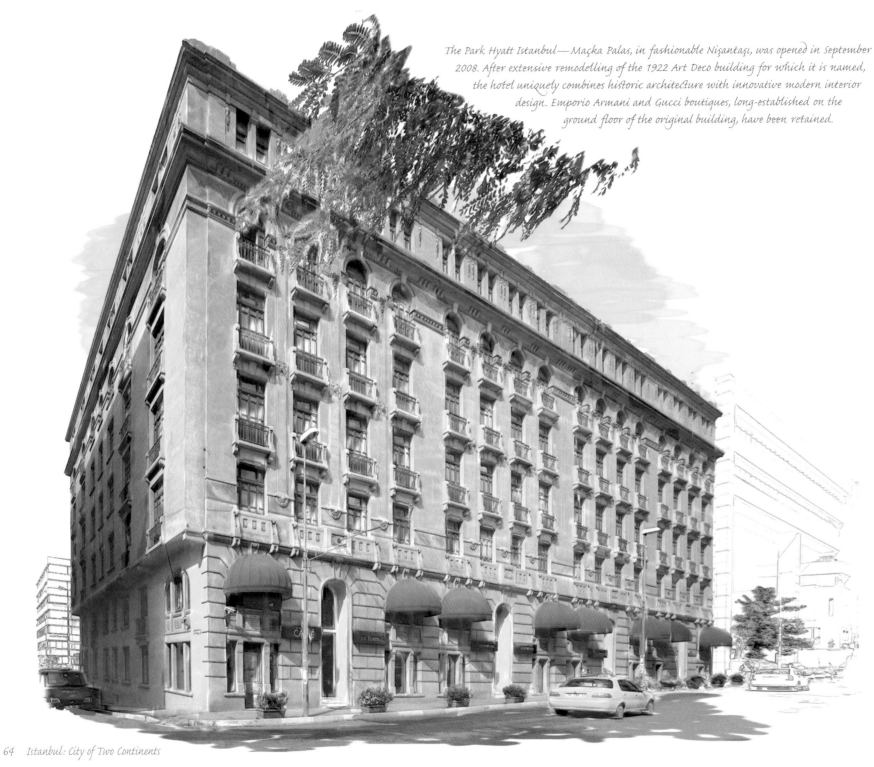

The Park Hyatt Istanbul—Maçka Palas, in fashionable Nişantaşı, was opened in September 2008. After extensive remodelling of the 1922 Art Deco building for which it is named, the hotel uniquely combines historic architecture with innovative modern interior design. Emporio Armani and Gucci boutiques, long-established on the ground floor of the original building, have been retained.

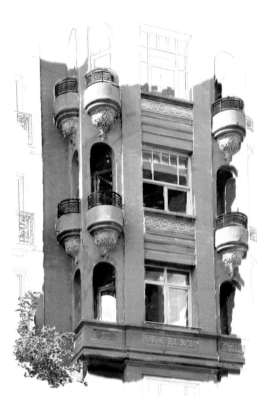

The Teşvikiye Palas apartment building in Nişantaşı is perhaps the most original of such buildings in an area of striking architecture. Part is now occupied by the honorary Mexican Consul.

The neo-baroque Teşvikiye Mosque was commissioned in 1794 by Selim III, but most of the current structure including the front which gives it its unique character was completed in 1854 during the reign of Abdül Mecit I. In his book Istanbul: Memories of a City, Nobel prize-winner Orhan Pamuk, whose family lived in Nişantaşı, recounts how the family maid took him here one afternoon on his first visit to a mosque.

Sited just north of Taksim Square, the Atatürk Library, designed by architect Sedad Hakkı Eldem, was opened in 1975. It was originally intended to be part of a cultural complex that would have included a museum.

In the foreground of the front entrance of Dolmabahçe Palace is the Swan Fountain. Now a feature of the formal Imperial Gardens that surround the palace, the fountain was previously in the harem gardens and before that at Yıldız Palace.

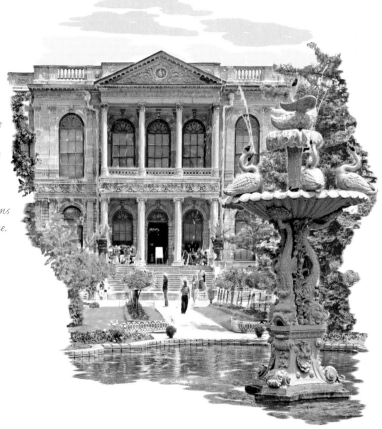

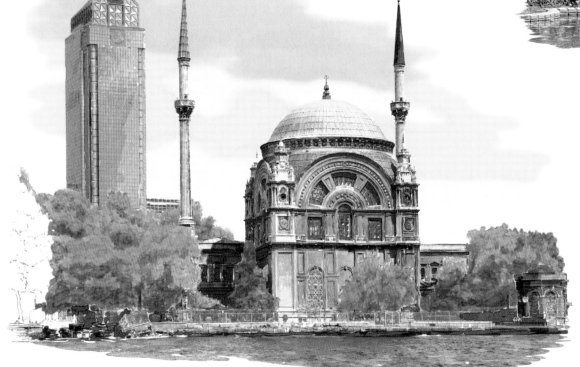

The baroque style Dolmabahçe Mosque, with its two slender minarets, stands on the shore of the Bosphorus in serene contrast to the controversial 'Gökkafes' (Skycage) building behind, in part occupied by the Ritz Carlton hotel.

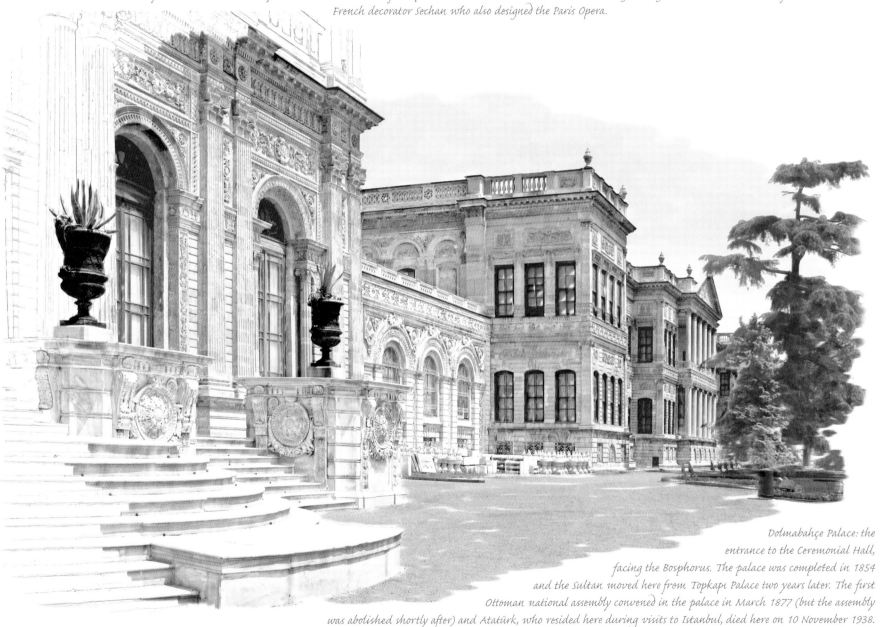

Dolmabahçe Palace, built in the royal gardens developed on land reclaimed from the Bosphorus early in the 17th century (thus the name —dolma bahçe—means 'the filled-up garden'), was designed to impress. And architect Nikoğos and his father Karabet Balyan's design for Abdül Mecit certainly does that. The interior of the palace—in all there are 285 rooms including 43 large salons—was the work of French decorator Sechan who also designed the Paris Opera.

Dolmabahçe Palace: the entrance to the Ceremonial Hall, facing the Bosphorus. The palace was completed in 1854 and the Sultan moved here from Topkapı Palace two years later. The first Ottoman national assembly convened in the palace in March 1877 (but the assembly was abolished shortly after) and Atatürk, who resided here during visits to Istanbul, died here on 10 November 1938.

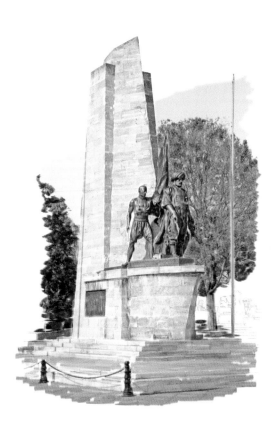

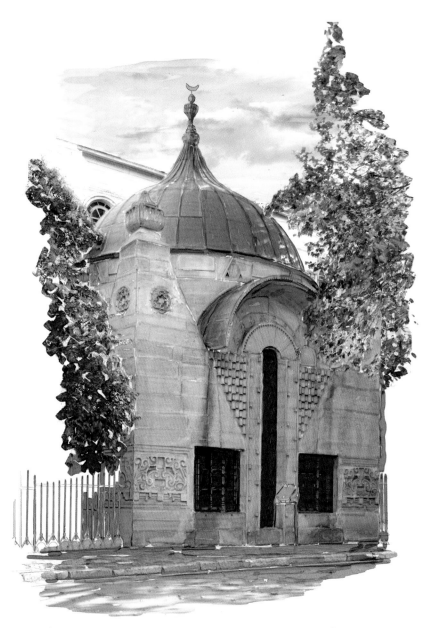

This statue on the square behind Beşiktaş pier commemorates Barbarossa (Red Beard), a pirate who was appointed by Süleyman the Magnificent as High Admiral of the Ottoman navy in 1533. In the next decade, almost single-handedly, he established Turkish sovereignty over much of the Mediterranean.

In the Şeyh Zafir complex in Beşiktaş, Imperial Architect Raimondo D'Aronco melded Ottoman architecture with Art Nouveau. The sketch is of the tomb in an ensemble that also includes a fountain and (unusually) a library. Abdül Hamit II commissioned the complex in honour of his spiritual councillor, Şeyh Mohammed Zafir, who died in 1903.

A Moorish style window in the Çirağan Palace, overlooking the Bosphorus. Designed by Sarkis Balyan and completed in 1874, the palace was gutted by fire in 1910. It was not until 1987 that it was completely rebuilt on the original foundations, preserving the exterior walls, and opened as a Kempinski Hotel.

Yıldız Park

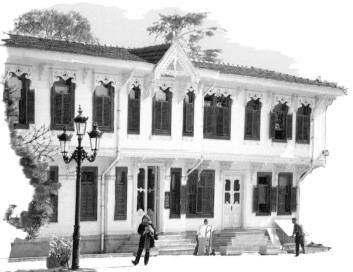

The Yaveran Dairesi is situated at the entrance to the grounds of Yıldız Palace, adjoining the wall to the inner garden. The building was commissioned by Abdül Hamit II (1876–1909) to accommodate high-ranking aides of the Sultan, and designed by Raimondo D'Aronco. The interior was rebuilt and the exterior restored by architect Aydın Yüksel in 1986.

Şale Köşkü is so named because of its resemblance to a Swiss chalet. The section shown here was added in 1889 to accommodate Kaiser Wilhelm II on the first state visit of a foreign monarch to the Ottoman capital, and through most of its history. Şale Köşkü was a guesthouse for visiting dignitaries: Winston Churchill, Charles de Gaule and Haile Selassie are among modern guests. Today some 50 of the palace's magnificent rooms are open to the public.

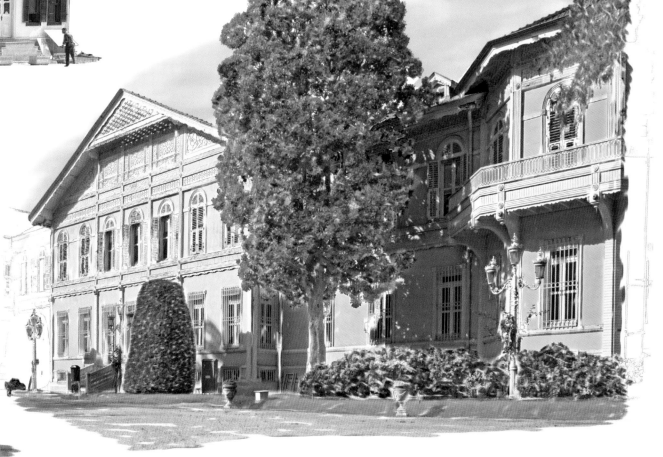

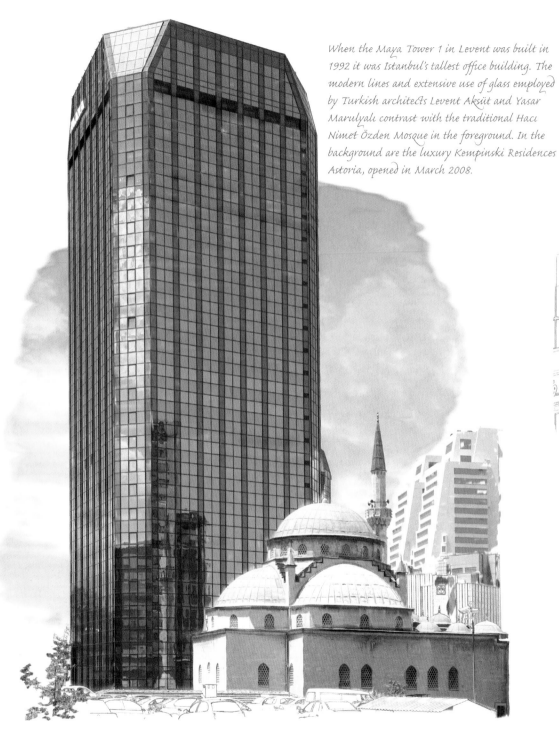

When the Maya Tower 1 in Levent was built in 1992 it was Istanbul's tallest office building. The modern lines and extensive use of glass employed by Turkish architects Levent Aksüt and Yasar Marulyalı contrast with the traditional Hacı Nimet Özden Mosque in the foreground. In the background are the luxury Kempinski Residences Astoria, opened in March 2008.

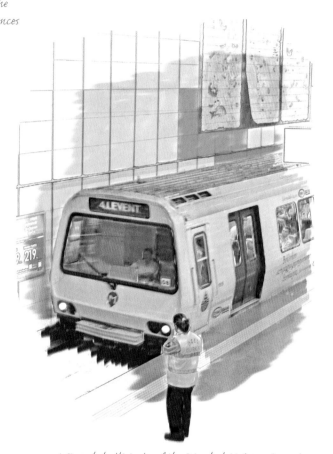

A French-built train of the Istanbul Metro system at Gayrettepe station. The subway system was initiated in 1992 and the first line of 6 stations between Taksim and 4th Levent went into service on 16 September 2000. It now carries 130,000 passengers daily. Extensions north from 4th Levent and south from Taksim across the Golden Horn and then beneath the old city are being planned.

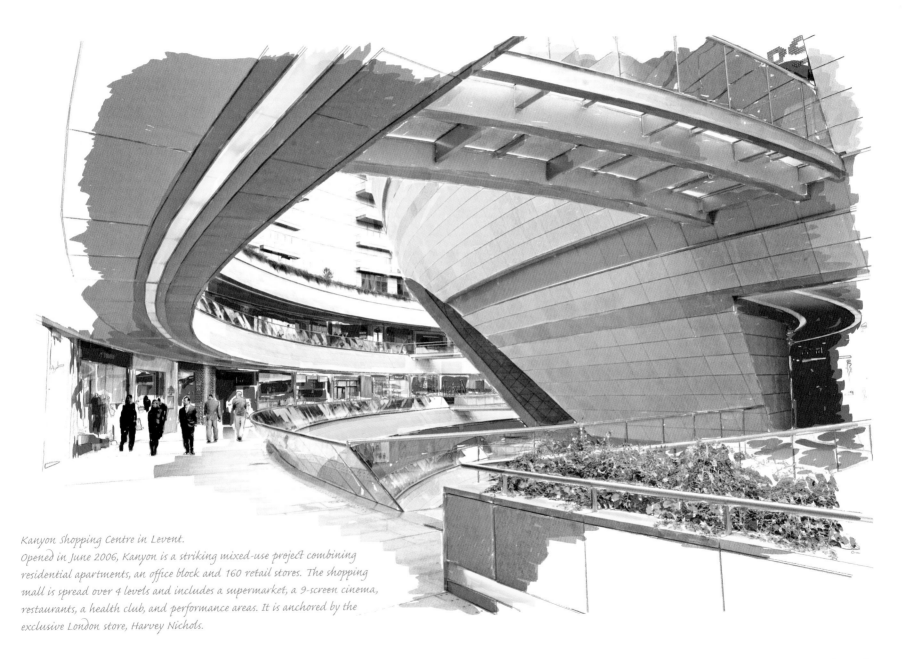

Kanyon Shopping Centre in Levent.
Opened in June 2006, Kanyon is a striking mixed-use project combining residential apartments, an office block and 160 retail stores. The shopping mall is spread over 4 levels and includes a supermarket, a 9-screen cinema, restaurants, a health club, and performance areas. It is anchored by the exclusive London store, Harvey Nichols.

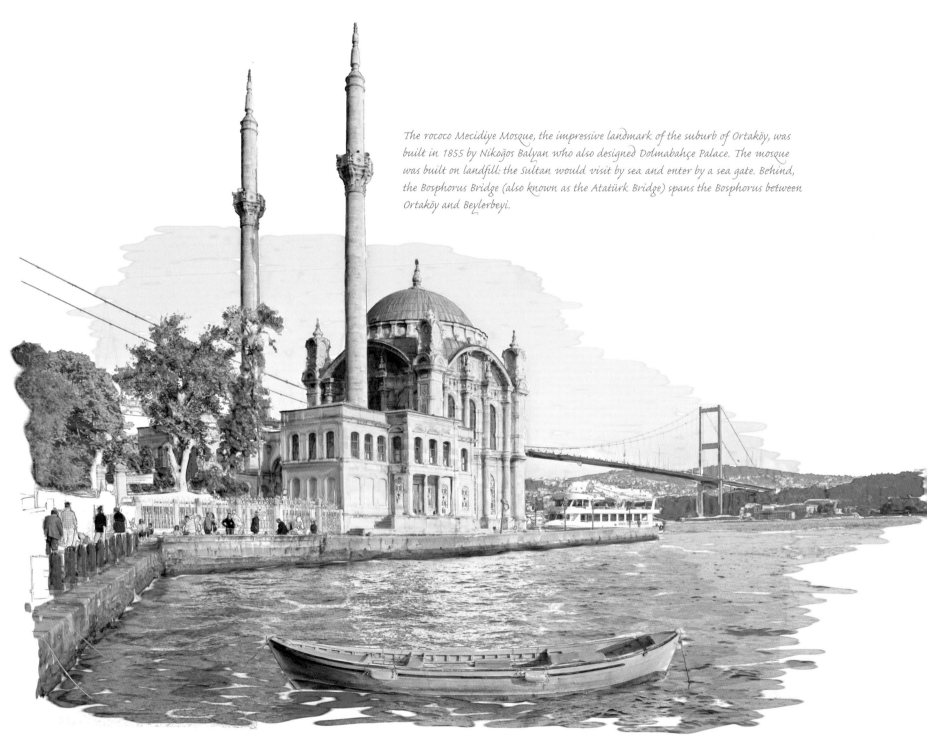

The rococo Mecidiye Mosque, the impressive landmark of the suburb of Ortaköy, was built in 1855 by Nikoğos Balyan who also designed Dolmabahçe Palace. The mosque was built on landfill: the sultan would visit by sea and enter by a sea gate. Behind, the Bosphorus Bridge (also known as the Atatürk Bridge) spans the Bosphorus between Ortaköy and Beylerbeyi.

Bebek

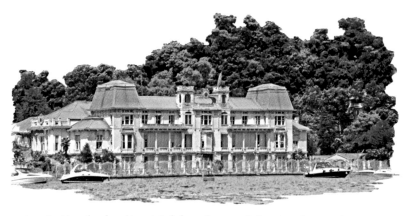

Dominating the shoreline at Bebek, and presently housing the Egyptian Consulate-general, is the largest Art Nouveau style building in Istanbul. It was commissioned by the Khediva-Mother Emine in 1902 and built in stages.

Aşiyan Museum is the former home of Tevfik Fikret, one of Turkey's most influential poets. He designed and built the wooden house himself, using buildings he saw in England as his inspiration, and called it 'Aşiyan' (Nest). It was purchased by the City of Istanbul in 1940 and now houses works, paintings and memorabilia of Fikret and other poets.

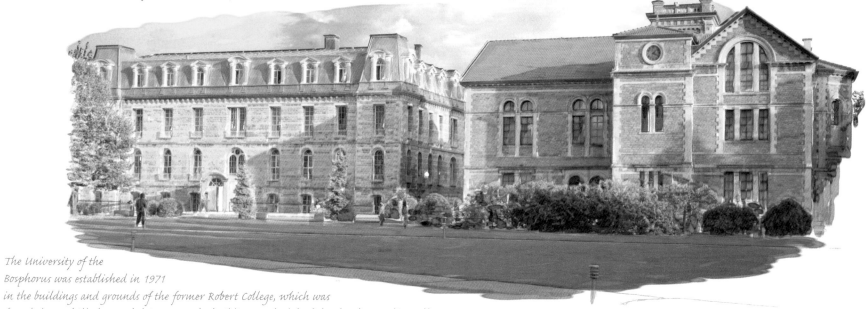

The University of the Bosphorus was established in 1971 in the buildings and grounds of the former Robert College, which was founded on a hill above Bebek in 1863. The building on the left of the sketch, Hamlin Hall, completed in 1871, is the oldest on the campus. It is now a men's dormitory. The blue limestone building on the right, Albert Long Hall, was completed in 1891. It is now the University Cultural Centre.

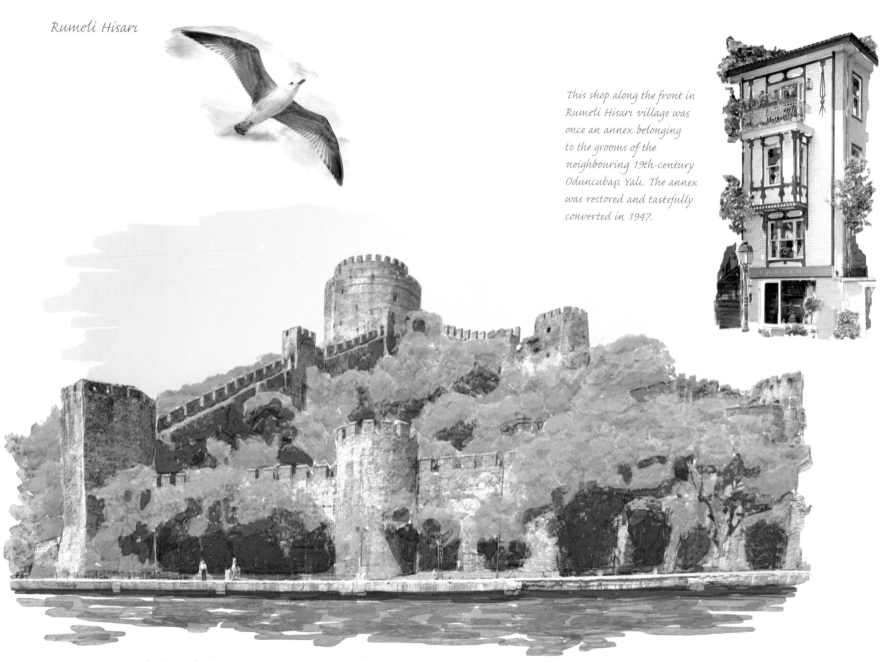

This shop along the front in Rumeli Hisarı village was once an annex belonging to the grooms of the neighbouring 19th-century Oduncubaşı Yalı. The annex was restored and tastefully converted in 1947.

Rumeli Hisarı, the 'Fortress of Europe', was built in four months by Mehmet the Conqueror in 1452 in preparation for his siege of Constantinople. Standing on the European shore opposite Anadolu Hisarı, built by his great-grandfather 60 years earlier at the narrowest point of the Bosphorus, it enabled Mehmet to blockade shipping from the Black Sea. It served its purpose: a year later the city fell.

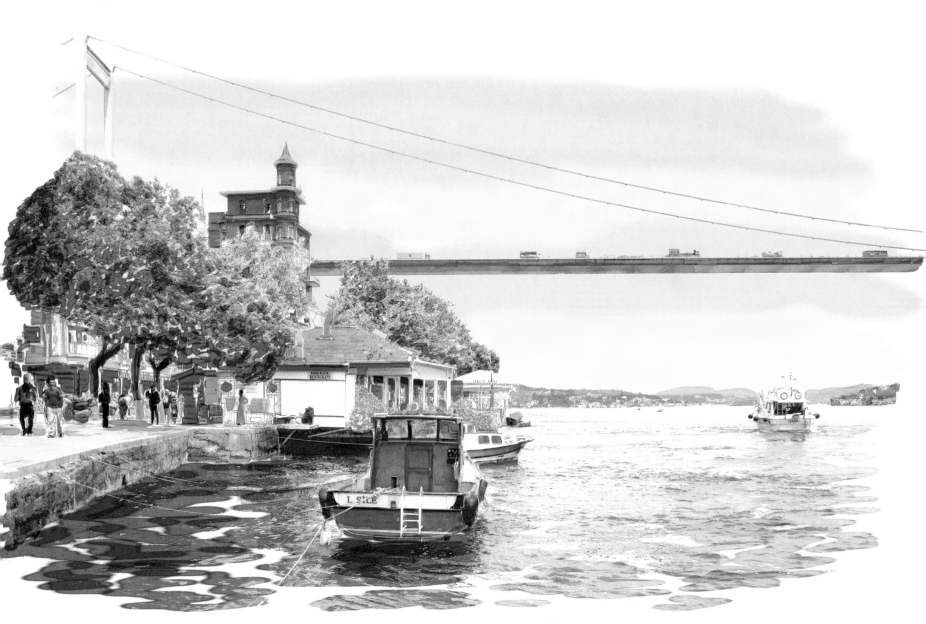

The front at Rumeli Hisarı, with the Fatih Sultan Mehmet Bridge above. The bridge was opened in 1988 just 2500 years after Darius the Great of Persia (r. 522–489 BCE) had a bridge of boats built across the Bosphorus at the same site. Like the Atatürk Bridge opened in 1973 (page 72) the structural design of the suspension bridge was by Freeman Fox & Partners, founded by Sir Ralph Freeman, the London-born designer of the Sydney Harbour Bridge.

The Other Side: Istanbul in Asia

The Asian shore of the Bosphorus is lined with picturesque *yalı*, many of them from the late Ottoman era. The yalıs extend as far as Üsküdar, the ancient Chrysopolis, on the Asian shore where the Bosphorus flows into the Sea of Marmara. Between the yalıs, two palaces grace the shore. The larger, Beylerbeyi, built for Abdül Aziz in 1865 as a summer lodge and a residence for visiting dignitaries, is now over-shadowed by the Bosphorus Bridge. Further north is Küçüksu, Little Stream, named after one of the rivers known to Europeans as the Sweet Waters of Asia. This pretty little edifice was built as a pied-a-terre for Abdül Mecit in 1857. Üsküdar is adorned with seven historic mosques, three of them built by Sinan, namely Iskele Camii (1548), Şemsi Ahmet Paşa Camii (1580) and Atik Valide Camii (1583), which rivals the Süleymaniye in its grandeur.

The red mansion perched on the heights above the Marmara beyond Üsküdar is the Muharrem Nuri Birgi Konak, dating from the late eighteenth century and now superbly restored. The three enormous structures, landmarks along the shore, to the south are the Selimiye Barracks (1853),

which served as Florence Nightingale's Hospital during the Crimean War, the Haydarpaşa Lisesi (1893), originally the Military Medical Academy, and the Haydarpaşa Railway Station (1908).

There are ferry services out to the Princes' Isles, Istanbul's little archipelago off the Asian coast of the Marmara. The group consists of nine islands, all but four of them tiny. The four largest, with their Greek names in parentheses, are Kinali (Proti), Burgaz (Antigoni), Heybeli (Halki), and Büyükada (once known as Prinkipo in Greek). Private automobiles are banned on the islands, and so the only transport is by phaeton, or horse-drawn carriage. The islands are noted for their beautiful old mansions, particularly those on Büyükada. The higher of the two hills on Büyükada is surmounted by the Greek monastery of Ayios Yorgios, whose feast day on 23rd April is celebrated by pilgrims from all over the Orthodox world as well as by Muslims. The view from the monastery is superb, particularly toward sunset, when the domes and minarets of Istanbul are silhouetted on the maritime boundary of Europe and Asia.

The 830-ton dry cargo ship 'Adil Kaptan', built in Istanbul in 1972 as the 'Yenipazarli III', is one of some 55,000 ships that traverse Istanbul annually by the narrow strait—appropriately called 'the throat' (Boğaz) in Turkish. This traffic includes an average of six modern tankers a day which, in a year, carry over 140 million tonnes of oil products.

One of two pavilions on the pier wall in front of
Beylerbeyi Palace where men and women waited
separately to cross the Bosphorus. Described by one
writer as 'a parody of Ottoman architecture', the
tent roof is a reminder of the nomadic origins of
the Ottomans.

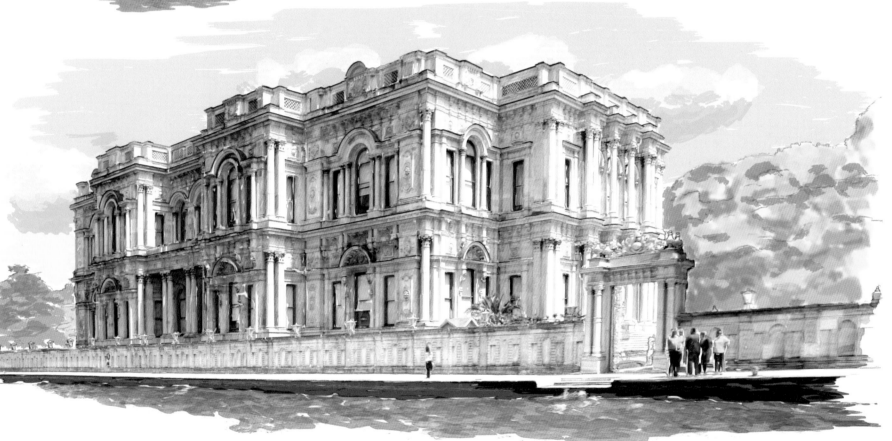

Beylerbeyi Sarayı, the largest Ottoman palace on the Asian Shore, was used both as a summer palace and as a residence for visiting royalty, the first of whom was
the Empress Eugenie of France on her way to the opening of the Suez canal in 1869. Restored, the palace is now a museum.

Küçüksu Kasrı is a delightful small baroque palace on the Asian shore of the Bosphorus. It is named Küçüksu (Small Water) after a neighbouring stream, one of the two comprising what is still fondly known as the 'Sweet Waters of Asia'.

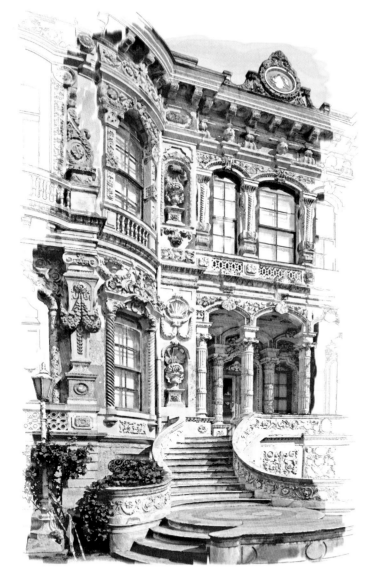

An embellished baroque staircase leads up from the first floor.

Clocks in the pavillion are stopped at 9:05, the time of the death, on 10 November 1938, of Kemal Atatürk, who stayed here frequently.

The exaggerated rococo decoration of the front façade was added during the reign of Abdül Aziz (1861–76). The palace was used as a guesthouse by both Abdül Aziz and Abdül Hamit II (Edward, Prince of Wales was one guest), and during the Republican era. It was transformed into a delightful museum in 1983 and was restored in 1994.

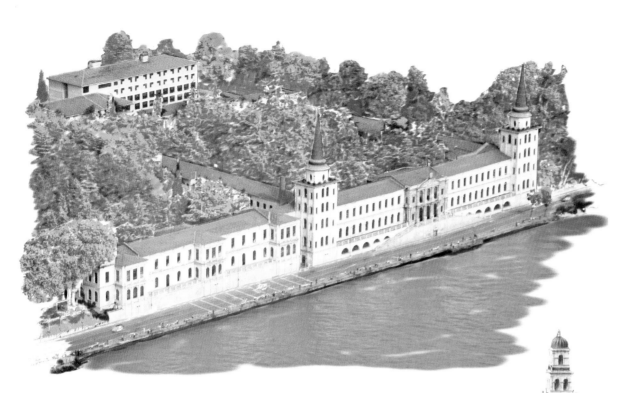

The empire style Kuleli ('towered') Military High School was commissioned as a barracks in 1863. A hospital was added in 1893 and the new wing on the left in 1909. Along with the Selimiye barracks (below), an earlier training school and barracks built here about 1800 were used as a military hospital during the Crimean war.

The Aberdeen granite obelisk, erected in 1857 at the entrance to the carefully tended lawns of the Crimean War Cemetery, bears a tribute 'by Queen Victoria and her people'. It also carries a plaque, dedicated by Queen Elizabeth II during her state visit in 1971, honouring the work of Florence Nightingale and her nursing staff, several of whom are buried here.

The Selimiye Barracks in Üsküdar, built in 1826 and enlarged between 1842 and 1853, is still in use by the Turkish army. During the Crimean War, it was a British military hospital and it was here that Florence Nightingale and her nurses tended casualties. A museum honouring Florence Nightingale is in the ground floor of the north tower, shown on the left.

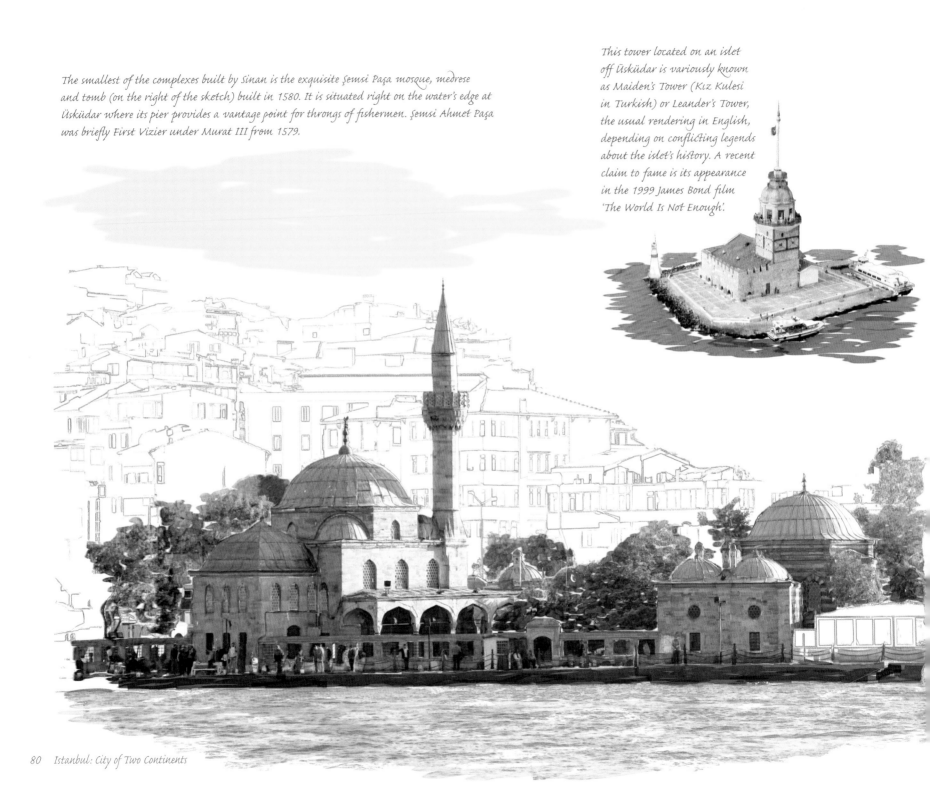

The smallest of the complexes built by Sinan is the exquisite Şemsi Paşa mosque, medrese and tomb (on the right of the sketch) built in 1580. It is situated right on the water's edge at Üsküdar where its pier provides a vantage point for throngs of fishermen. Şemsi Ahmet Paşa was briefly First Vizier under Murat III from 1579.

This tower located on an islet off Üsküdar is variously known as Maiden's Tower (Kız Kulesi in Turkish) or Leander's Tower, the usual rendering in English, depending on conflicting legends about the islet's history. A recent claim to fame is its appearance in the 1999 James Bond film 'The World Is Not Enough'.

The yalı was superbly restored in 1968–71 and its restrained exterior and spacious interior, which evince the classical age of Ottoman style, and its fine collection of Ottoman artefacts, are all lovingly preserved by its current owner, Selahaddin Beyazıt.

The Çürüksulu Mehmet Paşa Yalısı dates from the 18th century. Later the home of ambassador Muharrem Nuri Birgi, the beautiful wooden house stands high on a cliff at Salacak overlooking Maiden's Tower.

The Atik Valide Mosque—Üsküdar.

Sinan's last major work, the mosque and its extensive complex is surely one of the most splendid in Istanbul, and indeed is rated among the most impressive monuments of Ottoman architecture in the whole of Turkey.

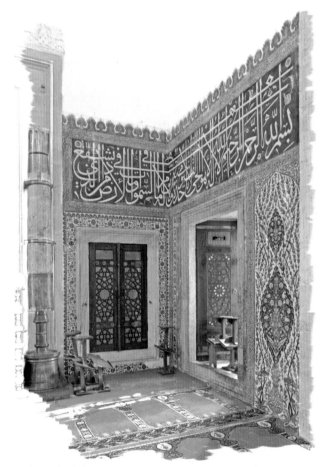

The mihrab apse is almost completely covered with panels of the finest Iznik tiles including rows of inscriptions and a design with trailing blossoms and vases of tulips.

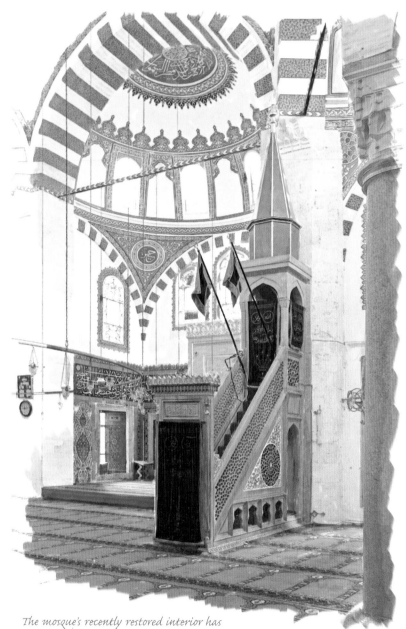

The mosque's recently restored interior has a lightness and delicacy that is particularly appealing and the marble mimber is beautifully carved.

The late-prayer's porch, in the gracefully covered gallery on the entrance side of the mosque, which is still decorated with the original ornamental paintings.

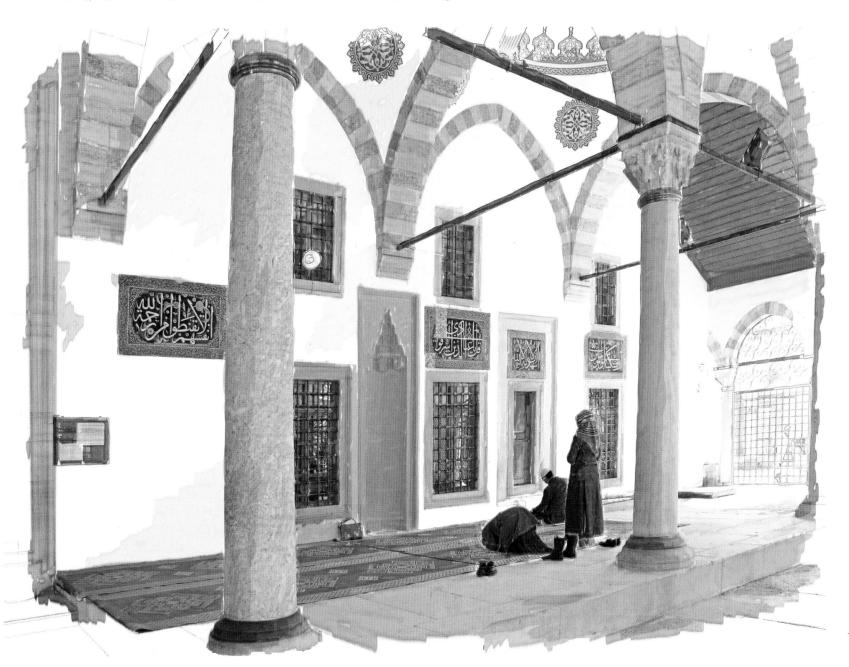

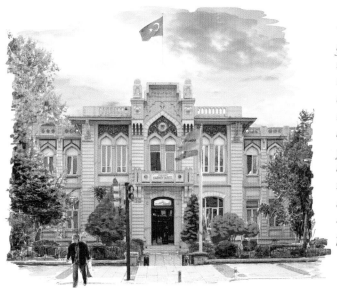

This attractive municipal government building on Kadıköy square was designed by Konstantinos P. Kyriakides around 1910. It was from its balcony that Halide Edip Adıvar (1884–1964), a distinguished scholar, novelist, feminist, nationalist fighter, and sometime press advisor and secretary to Mustafa Kemal, later Atatürk, addressed the crowd at one of the mass meetings in 1919 protesting the occupation of Izmir.

The neo-Renaissance forms of the opulent exterior of Haydarpaşa Station (opposite) are echoed in the rich decorations of the large booking hall by Italian painter Luigi Leone (b. 1853).

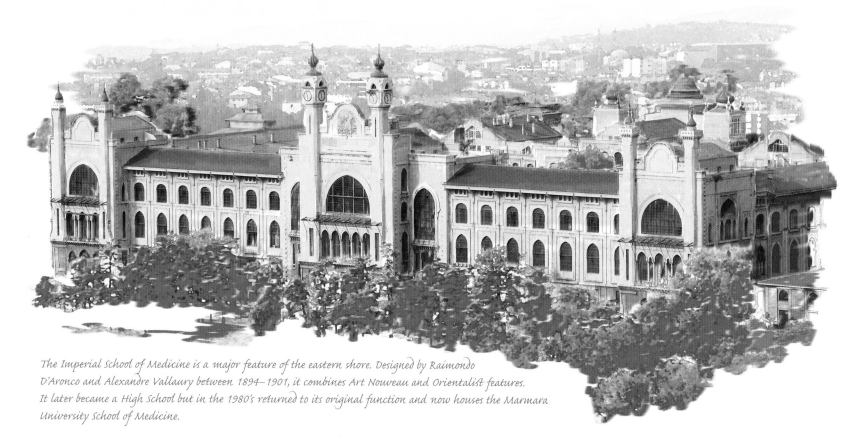

The Imperial School of Medicine is a major feature of the eastern shore. Designed by Raimondo D'Aronco and Alexandre Vallaury between 1894–1901, it combines Art Nouveau and Orientalist features. It later became a High School but in the 1980's returned to its original function and now houses the Marmara University School of Medicine.

Haydarpaşa Station, terminus of the Istanbul-Baghdad and Istanbul-Damascus-Medina railways, was built in 1906–08 by the German architects, Otto Ritter and Helmut Cuno. It was opened by Kaiser Wilhelm II on his second state visit to Istanbul in 1898—although the line to Baghdad was still not finished on the Kaiser's final visit late in World War I. A ferry, typical of the many plying between the European and Asian shores of the Bosphorus, passes before the station as it approaches Kadıköy pier. The ship is named for Barış Manço (1943–1999) a much beloved Turkish singer, composer, television producer and celebrity, and a graduate of Galatasaray Lisesi (page 58) where he formed his first band.

Istanbul, a popular starting point for sailing, is served by two large yacht harbours, one on each shore. Kalamuş Marina, on the Asian side near Kadıköy, is a full-service marina capable of handling nearly 1,200 yachts—and is also a favoured dining venue.

The Moda Ferry Pier in Kadıköy, a fine example of late Ottoman style, is built on a breakwater. Architect Vedad Tek Bey (page 94) gave each façade a different design. Built in 1917, it was closed to transport from 1985, restored, and reopened in 2000.

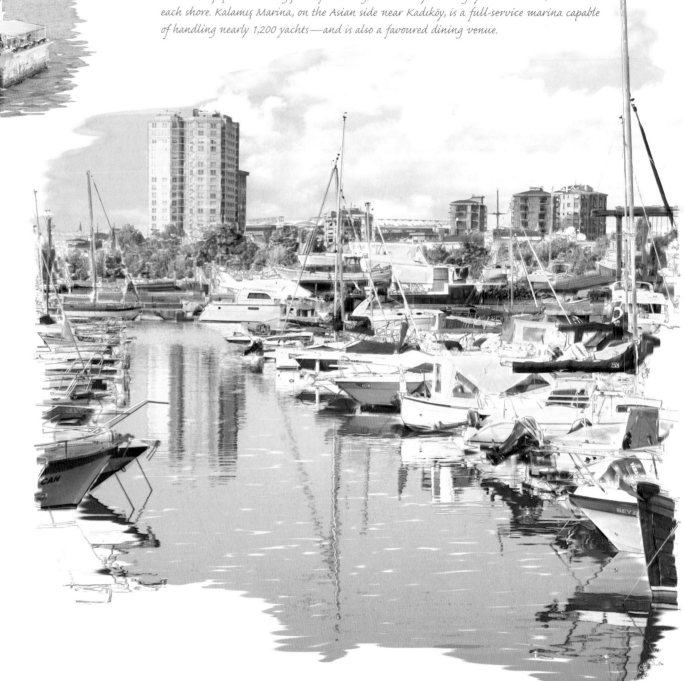

The Fenerbahçe Sports Club, whose flag is shown here, was founded in 1907. It is famous for its football team, known simply as Fenerbahçe and nicknamed the Yellow Canaries for its yellow-backed shirts. It is the most successful Turkish football team of all time, having amassed over 100 titles in its one hundred-year history. It claims to have 25 million fans.

One of Istanbul's ubiquitous yellow taxis passes the Şükrü Saracoğlu Stadium, outside Kadıköy, home of the Fenerbahçe football team. Opened in 1908 and recently renovated, the stadium, with a capacity of 52,500, is the biggest club stadium in Turkey. It has been selected to host the 2009 European FA Cup Final. The stadium was designed by architects Zeha Aksu and Adnan Aksu and is named for the fifth Prime Minister of Turkey (1942 to 1946), who was Chairman of the club from 1934 to 1950.

Bağdat Caddesi—'Istanbul's Fifth Avenue'

A popular shopping street, Bağdat Caddesi is often referred to as the Asian side's answer to Nişantaşı or, with some hyperbole, the Fifth Avenue of Istanbul. Its wide sidewalks, shaded by plane trees, are lined with elegant shops stocking international brands, department stores, cafés and restaurants.

A colourful flower stall on a shady sidewalk along Bağdat Caddesi.

Advertising standards are part of the commercial landscape of Bağdat Caddesi, a road that was used for trade and military purposes during both the Byzantine and Ottoman periods. The old route was named after Baghdad following the recapture of that city by Murat IV in 1638.

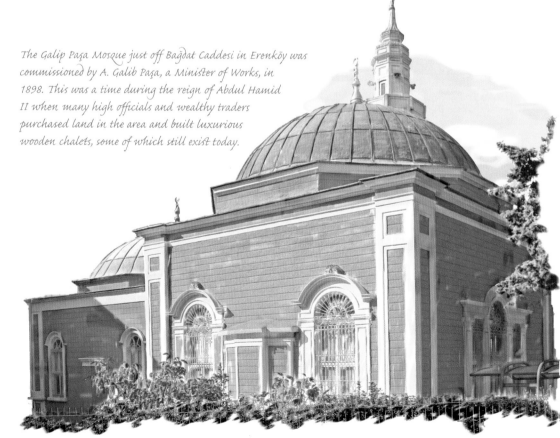

The Galip Paşa Mosque just off Bağdat Caddesi in Erenköy was commissioned by A. Galib Paşa, a Minister of Works, in 1898. This was a time during the reign of Abdul Hamid II when many high officials and wealthy traders purchased land in the area and built luxurious wooden chalets, some of which still exist today.

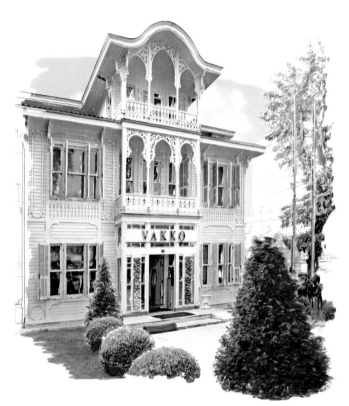

The Vakko store on Bağdat Caddesi, in the wealthy Suadiye area, is a sympathetic conversion of a private mansion dating from the 1920s. Vakko, the quintessential fashion house of Turkey, specialises in clothing and accessories.

International shopping on Bağdat Caddesi: the London outfitters Burberry is one of many West European stores to be found on the tree-lined boulevard. Thomas Burberry, a draper's assistant, founded the store in Basingstoke, England, in 1856 and it now has branches round the world.

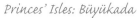

Princes' Isles: Büyükada

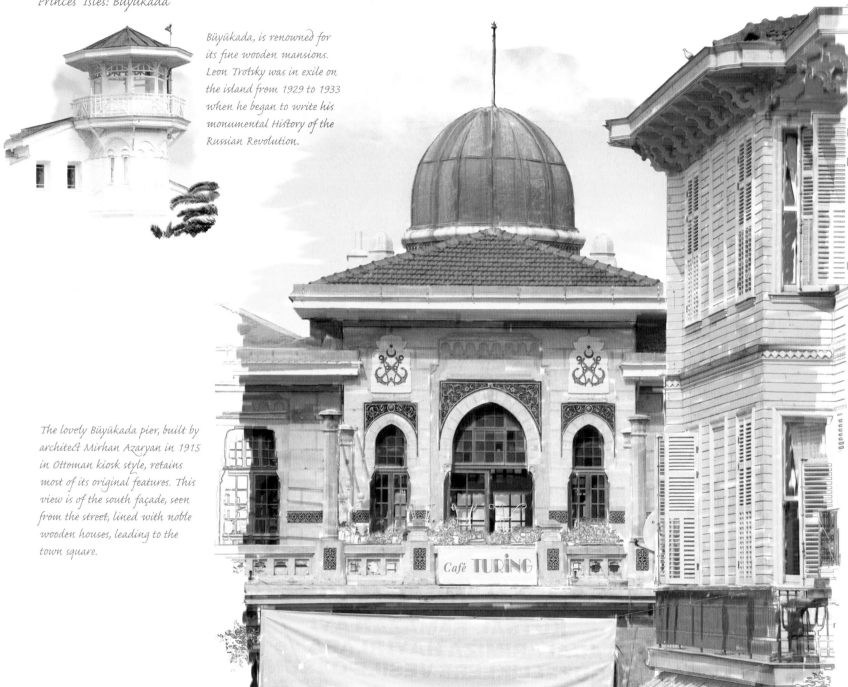

Büyükada, is renowned for its fine wooden mansions. Leon Trotsky was in exile on the island from 1929 to 1933 when he began to write his monumental History of the Russian Revolution.

The lovely Büyükada pier, built by architect Mirhan Azaryan in 1915 in Ottoman kiosk style, retains most of its original features. This view is of the south façade, seen from the street, lined with noble wooden houses, leading to the town square.

Café TURING

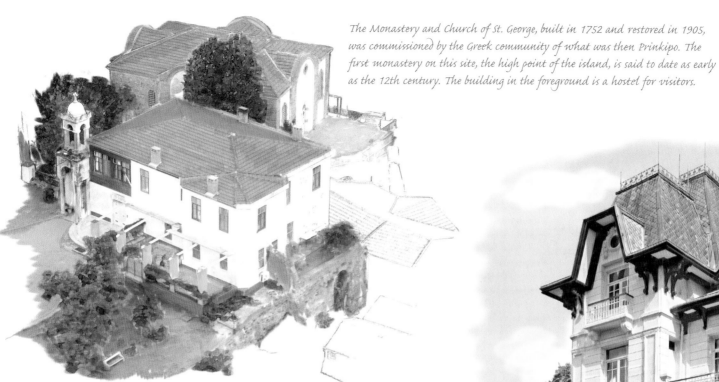

The Monastery and Church of St. George, built in 1752 and restored in 1905, was commissioned by the Greek community of what was then Prinkipo. The first monastery on this site, the high point of the island, is said to date as early as the 12th century. The building in the foreground is a hostel for visitors.

The taxi rank outside the Splendid Hotel. One of the attractive features of the Princes' Islands is that there are no private motor vehicles: the major form of transport is a horse-drawn phaeton.

The Anadolu Club (Anadolu Kulübü Binası) was founded in the 19th century as the British Yacht Club. It was taken over in the early days of the Republic and made into a resort for parliamentarians. Today every Turkish deputy becomes a life member of this very exclusive establishment.

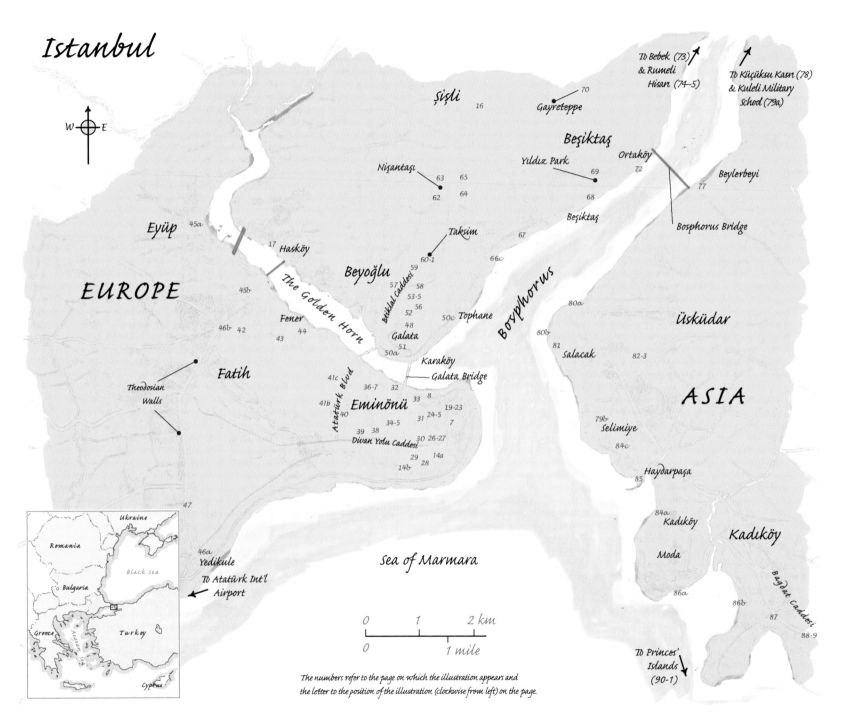

Istanbul

W—E

Şişli

16

70

Gayreteppe

To Bebek (73)
& Rumeli
Hisarı (74–5)

To Küçüksu Kasrı (78)
& Kuleli Military
School (79a)

Beşiktaş

Nişantaşı

63 65

62 64

Yıldız Park 69

Ortaköy
72

Beylerbeyi

68

77

Beşiktaş

Eyüp 45a

Taksim

67

Bosphorus Bridge

17 Hasköy

Beyoğlu

60-1

66c

Bosphorus

EUROPE

45b

59

İstiklal Caddesi

57 58

Üsküdar

53-5 56

80a

52

Fener

48

50c Tophane

46b 42

44

Galata

80b

ASIA

43

51

81 Salacak

82-3

50a

Karaköy

Theodosian
Walls

Fatih

Galata Bridge

79b Selimiye

41c

36-7 32

84c

40 33 8

41b

Eminönü

19-23

Atatürk Blvd

34-5 31 24-5 7

39 38

Haydarpaşa

Divan Yolu Caddesi 30 26-27

85

14a

84a
Kadıköy

28

14b

Moda

Kadıköy

47

Bağdat Caddesi

86a

46a
Yedikule

Sea of Marmara

86b

To Atatürk Int'l
Airport

87

88-9

0 1 2 km

0 1 mile

To Princes'
Islands
(90–1)

Romania

Ukraine

Bulgaria

Black Sea

Greece

Aegean Sea

Turkey

Cyprus

The numbers refer to the page on which the illustration appears and
the letter to the position of the illustration (clockwise from left) on the page.

Glossary

Caddesi, avenue, road
Cami, Camii, mosque
Çarşı, Çarşısı, market
Han, Hanı, an Ottoman inn for travellers, usually with workshops and storage facilities
Hamam, a Turkish bath
Harem, private section for women in a home
Hisar, Hisarı, fortress
Kapı, Kapısı, gate
Kasr, Kasrı, a small palace, pavilion
Konak, an inland mansion
Külliye, mosque complex
Medrese, Islamic school

Meydan, Meydanı, square
Meyhane, tavern, eating house
Mihrab, a niche in a mosque wall indicating the direction of Mecca
Mimber, the pulpit in a mosque
Müze, Müzesı, museum
Saray, Sarayı, palace
Sebil, a water distribution point
Sokak, Sokağı, street, lane
Tuğra, a monogram in highly formalised artistic calligraphy
Türbe, tomb, mausoleum
Vizier, a Sultan's minister
Yalı, Yalısı, a water-side mansion on the Bosphorus

Gazetteer

CITY OF TWO CONTINENTS

Page 8
Sirkeci Station (Opened as Müşir Ahmet Paşa Station, 1890)
Sirkeci İstasyon Caddesi, Sirkeci, Eminönü
The station's architect was August Jasmund, a Prussian lecturer at what is now Istanbul Technical University, and tutor of Kemalettin Bey, one of the leaders of the First National Architectural Movement (see page 94). Jasmund's design combined neo-classical symmetry with a variety of Ottoman features: the two towers on either side of the Seljuk style main portal were originally topped with onion domes.

Page 10
Istanbul Metro's modern tramway (Initiated 1992)
When opened, the tramway connected Sirkeci with Topkapı, just beyond the Theodosian walls, and was continued to Zeytinburnu in March 1994. In January 2005, it was extended from Sirkeci across the Golden Horn to Kabataş (from where an underground funicular connects to the metro terminal at Taksim). The 14-km line has 24 stations.

Page 15
The Four Seasons Hotel (Built as a prison, 1919, converted 1994)
Kutlugün Sokak, Sultanahamet
The design of the original prison is variously attributed to Kemalettin Bey and another of the foremost practitioners of the First National architectural style (page 94), Vedat Tek Bey. Tiles used on the exterior are by a tile master of the period, Kütahyalı Hafız Mehmed Emin. After the prison closed in 1969, the building had a chequered career that included a further few years as a detention centre for political prisoners. It was not until 1994 that work was started by architect Yalçın Özüekren and interior designer Sinan Kafadar to convert it to a hotel retaining, as far as possible, the original architectural features.

Page 16
Cevahir Mall (Opened October 2005)
22 Büyükdere Caddesi, Şişli
The project was originally for a large trade complex designed in 1987 by American architects Minoru Yamasaki & Associates, but only the shopping centre section was completed. Can Yavuzarslan, a Turkish-British architect, also took part in the creation of the mall.

Page 17
Rahmi M. Koç Museum
Hasköy
The museum's eclectic collection focuses on means of transport—from a submarine to an aircraft—but includes engineering, scientific instruments and communications, all clearly and meticulously documented. The museum was first opened in 1994 and greatly expanded in 2001, following the purchase of the former Hasköy shipyard.

THE HISTORIC HEART OF ISTANBUL

Pages 18–23 and 11
Topkapı Palace (Built 1459–1465, Harem added c. 1588, later additions)
Topkapı Sarayı Müzesi, Sarayburnu
Shortly after his Conquest of Constantinople, Mehmet II built Topkapı Sarayı as his principal residence on what had been the acropolis of ancient Byzantium. It is a series of pavilions within four expansive courtyards, surrounded by a defensive wall, the now-lost main sea-gate of which, the Cannon Gate, *Top Kapı*, gave its name to the whole complex. Initially the palace included the seat of government, the Divan, where the Viziers of the imperial council met, and a school for civil servants (the forerunner of Galatasaray Lycée (page 58)). In the 16th century, the government moved to the Sublime Porte (page 31). The Harem, laid out by Murat III in the late 16th century, is a maze of corridors and courtyards nearly an acre in extent. The complex, forbidden to all men except the Sultan, his sons and the black eunuchs, includes, in some 300 rooms, the residences of the Sultan's wives, concubines and children. In 1853, Abdül Mecit I abandoned Topkapı for Dolmabahçe Palace (pages 66–67). Developed over 300 years, the Harem was last occupied in 1909. The Topkapı palace was opened as a museum of unrivalled collections in 1924.

Page 24
The Archeological Museum
Osman Hamdi Bey Yokuşu, Gülhane
The porticos of architect Alexandre Vallaury's original neo-Grecian building were designed after the 4th century BCE Sarcophagus of the Mourning Women that is in the museum. Wings were added between 1891 and 1907, and a four-storey annex was opened in 1991 on the one-hundredth anniversary of the museum's opening.

Sinan (c.1491–1588): Imperial Architect
Sinan was born in Ağınas village in Kayseri Province. At about the age of 21, he was conscripted into the Sultan's service, and then recruited into the elite Janissary corps in which he served with distinction as a military engineer. He was appointed Imperial Architect under Süleymaniye the Magnificent in 1538, and over the next 50 years, under 3 Sultans, was to design, supervise, build or restore as many as 477 buildings. Of these 316 were in Istanbul, of which some 120 are extant. These include his masterpiece, the Süleymaniye (pages 12 and 36–37), the Şehzade Mehmet Mosque complex and tomb (page 41), the Hamam of Roxelana (page 27), the Rüstem Paşa Mosque (page 32), Sokollu Mehmet Paşa Mosque (page 14), several buildings in Topkapı Palace including Murat III's Salon (page 22), the Kılıç Ali Paşa complex at Tophane (page 50) and—at Üsküdar—the Şemsi Ahmet Paşa complex (page 80) and the wonderful Atik Valide complex (pages 82–83).

The **Alexander Sarcophagos,** a fine and well-preserved example of Greek funerary art, belonging to Abdalonymos, King of Sidon (d. 312 BCE), was unearthed by Osman Hamdi Bey, the first professional archaeologist in Turkey, in 1887.

Pages 26–27
Haghia Sophia (532–37 CE, major restorations 563, 1353, 1847–49)
Sultanahmet Meydanı
The central design of Haghia Sophia, the third structure of that name on this site, was the work of two mathematicians, Anthemius of Tralles and Isidorus of Miletus. However, earthquake damage led to major changes (including a restructuring of the great dome—the largest in the antique world) by Isidorus' nephew, and the addition of the massive buttresses we see today. The four minarets were added at various times in the 16th century. The building was restored between 1847 to 1849 by the Swiss-Italian architects Gaspare and Guiseppe Fossati.

Page 28, endpapers
Sultan Ahmet Camii: the Blue Mosque (1609–1616)
Sultan Ahmet Külliyesi, Sultanahmet
The design of architect Sedefkar Mehmet Ağa, formerly a pupil and senior assistant of Sinan, follows the symmetrical composition of Sinan's first masterwork, the Şehzade Mosque, but also borrows elements from the nearby Haghia Sophia. Inside, the prayer hall is topped by an ascending system of domes and semi-domes, culminating in the central dome, which is 23.5 m (77 ft) in diameter and 43 m (141 ft) high at its centre: huge, but less than those of both Haghia Sophia and Sinan's Süleymaniye. The walls are lined with more than 20,000 handmade ceramic tiles, made at Iznik under the supervision of the master potter Kâşici Hasan in more than fifty different designs. More than 200 stained glass windows with intricate designs admit natural light, today assisted by chandeliers.

Page 29
İbrahim Paşa (d. 1536)
İbrahim Paşa, a Greek convert to Islam and an inseparable companion of Prince Süleyman, was appointed Grand Vizier shortly after Süleyman's accession and a year later married the Sultan's sister. He was an effective administrator and military commander but his arrogance and assumption of power aroused the ire of Süleyman's wife, Roxelana, and one morning in 1536, after he had dined privately with the

Sultan at Topkapı Palace and spent the night there, İbrahim Paşa's strangled body was found outside the gate. His wealth, including his great palace, was confiscated by the state.

Fountain of Kaiser Wilhelm II (1901)
Sultanahmet Meydanı
The neo-Byzantine style fountain's design was by Max Spitta with mosaics by August Oetken and inscriptions were by Ahmet Mutar Bey. The monograms of Abdül Hamit II and Wilhelm II on the stonework are to symbolise their political union.

Page 30
The Basilica Cistern (The Underground Palace – Yerabatan Sarayı) (c. 532 CE)
Yerabatan Caddesi, Sultanahmet
Built at the same time as Haghia Sophia, Justinian's impressive underground cistern is the only one broadly in its original condition. Its skilfully engineered brick vaults, 8 m high, are supported by 336 columns arranged in 12 rows of 28 each, and mainly topped with Corinthian capitals. Much of the material was from older buildings: this includes two ancient classical pedestals in the form of Medusa heads—one inverted and the other on its side—and a column with peacock eye markings like those in the Forum of Theodosius (page 39) from which it may have been taken.

Çorlulu Ali Paşa Külliyesi (1707–1709, parts renewed late 18th century)
Divan Yolu, Çarşıkapı
The classical style mosque complex, built in 1707–09 for a Grand Vizier of Ahmet III, who was later to be executed by his master, is located close to the Grand Bazaar. The *medrese* illustrated is today the setting for carpet shops and a tranquil traditional outdoor café.

Page 32
Rüstem Paşa Mosque (Completed 1562)
Hasırcılar Caddesi, Eminönü
Rüstem Paşa (1500–61) was the son-in-law of Süleyman the Magnificent. He was appointed Grand Vizier in 1544 and, except for a 2-year break, held that office until his death, working throughout hand-in-glove with the Sultan's wife, Roxelana. The mosque was built on the site of a former Venetian burial ground in the heart of the bazaar section. In this cramped space, there was no room for a large courtyard but this was compensated by a larger than customary dome for a mosque not sponsored by an imperial patron and by the opulence of the interior.

Page 33
Central Post Office (1903–1909)
Büyük Postane Caddesi, Sirkeci
Vedat Tek Bey's work uses a combination of Ottoman and western architectural elements that exemplifies the First National Architectural Movement (see box below). This is especially apparent in the 15-m (50-ft) high, airy, interior—probably inspired by the soaring atriums typical of 19th century European banks—in which pointed arches are decorated with traditional style tiles that Tek designed himself.

Page 35
The Grand Bazaar (aka The Covered Bazaar – *Kapalı Çarşı*) (Founded c. 1460)
Kapalıçarşı, Beyazıt
The bazaar has evolved over 550 years since Mehmed II (1451–81) founded two secure trading halls as a source of income for the Ayasofya Mosque (today's Haghia Sophia Museum) close to his first palace built in the area where the university now stands.
At one time the Grand Bazaar was surrounded by some thirty han, or warehouses that provided storage space, offices and accommodation for traders. The earthquake in 1894 destroyed much of the area and today only 13 hans remain in or next to the Bazaar.

Pages 36–37, 12
The Süleymaniye
Süleymaniye Külliyesi, Süleymaniye
Architect Sinan started work on the biggest of his Imperial buildings in 1550 with a year's work to level a terrace in the steep slope facing the Golden Horn. The mosque, in which Sinan adapted many features from Haghia Sophia, was completed in 1557. It has a square plan in which four great piers bear the soaring central dome, some 27 m in diameter—massive but still smaller than that of Haghia Sophia. The

remaining buildings in the *külliye*, finished two years later, are arranged around the terrace and include five *medrese*, a medical school, a hospital, and a caravanserai. To the south of the mosque is the cemetery, at the centre of which is the imposing octagonal tomb of Süleyman the Magnificent (d. 1566) and nearby that of his wife Roxelana (d. 1558).

Page 38
The University of Istanbul
Beyazıt Square, Beyazıt
After the establishment of the Turkish Republic, the University was modernised and installed in its present building, originally built for the Ministry of War, in 1864–66. It was designed by the French architect Marie-Auguste Antoine Bourgeois, who blended styles from different territories of the empire and the Islamic world. It was restored by Raimondo D'Aronco after the earthquake of 1894 and by E.H. Ayverdi in 1933 and 1950.

Page 42
The Kariye Museum, the Church of St. Saviour-in-Chora (1077–1081)
Kariye Camii Sokak, Edirnekapı
Founded by Maria Doukaina on the site of a 5th century church, the present structure underwent considerable remodelling between 1315 and 1321 at the time that its marvellous mosaics and frescoes were endowed by Theodore Metochites (1270–1331), a powerful Byzantine statesman and patron of the arts. It was converted into a mosque in 1510 and the mosaics and paintings were covered up with plaster and whitewash. The mosque was secularised in 1948 when a programme of restoration of the building and its decorations was begun by the Byzantine Institute of America and the Dumbarton Oaks Center for Byzantine Studies. It was opened as a museum in 1958.

First National Architectural Movement
The nationalist wave of 1908 lead to a renaissance in architecture that, building on the work of Raimondo D'Aronco (page 95), moved away from the imported flamboyance of the Balyans towards simplicity and a new use of features from classic Ottoman architecture—wide eaves, domes, pointed arches, overhangs, stalactite-like capitals and tiled facing. The pioneers of this movement were the Berlin-trained **Kemalettin Bey** (1870–1927) whose work in Istanbul included the Bebek Mosque and what is now the Merit Antique Hotel (page 39), and Paris University graduate **Vedat Tek Bey** (1873–1942), noted for the Post Office building (page 33), the Land Registry (page 29), his own house in Nişantaşı (page 63) and the Moda Ferry Pier (page 86). Another important member of the movement was the Istanbul-born Italian, **Giulio Mongeri**, a Milan-trained architect whose work between 1900 and 1930 included the elegant Maçka Palas (page 64) and the former Italian Embassy building opposite, and also St. Anthony's Church (page 53) in Beyoğlu.

The Church of St. Mary of the Mongols (13th century)
Firketeci Sokak, Fener
This Byzantine Church, dedicated to Theotokos Panaghiotissa, the All-Holy Mother of God, is also known as *Panaghia Mouchliotissa* (in Greek) or *Kanlı Kilise* (in Turkish), but its name in English is more descriptive of its history. For 15 years, Princess Maria Palaeologina was married to the Mongol Khan Abagu, great grandson of Genghis Khan, and lived in the Mongol court in Persia. Following Abagu's assassination she returned to Constantinople and, having spurned her father's wish to marry her to another Mongol Khan, around 1282, founded the church that is named for her and became a nun.

Pages 46–47
The Theodosian Walls (Mainly 447 CE with later extensions)
Over 6.5 km (4 miles) from the Sea of Marmara to the Golden Horn
Built in response to threats from Huns, Vandals and Germans who had already plundered Rome and were marauding across Europe, the walls enclosed some 14 sq km (5½ sq miles) of the peninsula, embracing a population estimated to be over 250,000. By the mid 20th century, the ravages of sieges, earthquakes, time and the needs of modern transport had shattered many towers, obliterated much of the outer walls, and caused breaches in the main defences. A major restoration programme was started in the 1980s with help from UNESCO. Among the earlier work to be completed was the Belgrad Kapısı, Belgrade Gate, restored by a team from Istanbul Technical University. The gate, known in Byzantine times as the Second Military Gate, gets its Turkish name from the artisans settled here by Süleyman the Magnificent after his capture of Belgrade in 1521.

ACROSS THE GOLDEN HORN: BEYOĞLU AND BEYOND

Page 48
The Galata Tower (1348)
Galata Kulesi Meydanı, Galata
When the Genoese built the tower, then known as the Tower of Christ, it was at the apex of a defensive wall. Through the Ottoman period and until 1960, it served as a fire-watch tower. It now caters to tourism. For many years it stood without its original conical roof: its exposed position made it susceptible to high winds. The roof was replaced by Köksal Anadol in a major restoration between 1964 and 1967.

Page 49
High-rise buildings in Şişli and Levent (1992–2008)
Conspicuous in the view are:
• on the right, the 143-m (469-ft) **TAT twin Towers**, each with 34 floors, owned by the Tatlıcı Group and opened in 2000 (Nikken Sekkei, Ltd., architects);
• right of centre, 3 white towers with black domes, the **Metrocity** shopping mall, office tower and 2 residential towers each of 31 storeys. Designed by Anthony Belluschi/OWP&P Architects of Chicago, it opened in 2003;
• left of centre, **Maya Tower 1** (see page 70) which from 1992 to 1993 was the tallest building in Istanbul at 110 m (361 ft): 15 years later it ranks 47th. The architects were Levent Aksüt and Yaşar Marulyalı;
• on the extreme left, the **Kempinski Residences Astoria**, also known as the Tatko Towers, opened in 2008 and 144 m (471 ft) high. (Architect: Ali Bahadır Erdin).

Page 51
Bankalar Caddesi and the Ottoman Bank Museum
35–37 Bankalar Caddesi, Karaköy
Historic Bankalar Caddesi (Bank Street)—also known as Voyvoda Caddesi, meaning 'Prince's Avenue' in Slavic—was the Wall Street of the Ottomans. It was here that Greek, Armenian and Jewish bankers created a full-fledged, modern banking system in the process of enabling the Ottomans to meet the enormous cost of the Crimean War. Although the majority of Istanbul's banks have now moved their headquarters to Levent and Maslak, a number of bank branches remain.
In the **Ottoman Bank Museum**, a display of Ottoman banknotes, shares, bound notebooks, bank and client records, and detailed personal information about each employee provides a fascinating glimpse into Turkish history. Central to the museum are several of the bank's original massive steel Chatwood's Patent Safes.
The twin buildings used today by the Ottoman Bank Museum, a corporation of Garanti Bank, and the Istanbul branch of the Central Bank of the Republic of Turkey, were completed in 1892, to the design of Alexandre Vallaury, whose Archeological Museum (page 24) had just opened. His stunning neo-classical façade, shown here, is on Bankalar Caddesi—the most important axis of Galata—while the rear façade, looking over the Golden Horn, displays strong Ottoman elements.

Page 54
Swedish Palace (1870)
Istiklal Caddesi
Built in 1870 as the embassy of the then United Kingdoms of Sweden and Norway, partly on the foundations of an earlier embassy constructed in 1704 and destroyed by fire in 1818, the Swedish Consulate-General building was designed by an Austrian architect, Domenico Pulgher (1837–1917). However, the striking gateway was a proposal of the then Minister Resident, Selim Ehrendorff. It was previously centred on a row of 8 shops, whose rents contributed to the legation. Happily, these were removed in 1963.

Page 60
Coffee in Europe
Not only was the first coffee shop opened in Istanbul but Turkey played a role in the spread of coffee drinking to western Europe. The first coffeehouse there was opened in Oxford in 1650 and two years later several more started in London, where they were identified by a wooden sign shaped to resemble a Turkish coffee pot. The Ambassador of the Ottoman Empire to France brought coffee to the court of Louis XIV around 1669 and the first café was opened in Paris in 1686. Coffee reached Vienna in 1683, after the city had been besieged in war with the Turks. Here it was introduced by a Polish army officer who had previously lived in Turkey—and was the only person there who knew how to use coffee seized from the retreating Ottoman army.

Page 62
The Military Museum (*Askeri Müze*) (Built 1887, converted 1964–1991)
Cumhuriyet Caddesi, Harbiye
Originally a barracks commissioned by Abdül Hamit II, major changes were made to the plan and façades by Professor Nezih Eldem during his remodelling from 1964 to 1991 to convert it into the museum. A splendid array of ancient cannon, more recent artillery pieces and aircraft adorn the grounds, and the museum has a fascinating collection of uniforms, swords, shields and firearms, standards and tents.

Page 64
The Park Hyatt Istanbul – Maçka Palas (1922, remodelled 2006–2008)
Bronz Sokak 35, Teşvikiye
The famed Maçka Palas was originally designed as a rental property by architect Giulio Mongeri for Vincenzo Caivano, a wealthy Italian tradesman, in a style reminiscent of the Milan palazzos. Mongeri, grandson of an Italian family long-established in Istanbul, was a pioneer of the First National Architectural Movement (see page 94) and was responsible for several buildings in Istanbul including St. Anthony's Church in Pera (page 53) and for the plinth of the Taksim Memorial (page 61). Randolph Gerner, principal of GKV Architects, a New York City-based architecture and design firm, was responsible for restoration of the façade and for the interior design of 85 guestrooms and 5 penthouse luxury suites.

Page 66
Dolmabahçe Mosque (1855); Ritz Carlton Hotel (2001)
Dolmabahçe Caddesi, Beşiktaş; Askerocağı Caddesi, Dolmabahçe
Architect Karabet Balyan's mosque was commissioned by the mother of Sultan Abdül Mecit I, Valide Sultan Bezmialem. On her death, the work was continued by her son and completed in 1855. The hotel building was designed by Mehmet Doruk Pamir and opened in 2001.

Page 68
Statue of Barbarossa
Iskele Caddesi, Beşiktaş
The fine bronze statue by Zühtü Müridoğlu was unveiled in 1946 on the 400th anniversary of

Raimondo D'Aronco, architect (1857–1932)
D'Aronco, an Italian professor of architecture, was sent by his government to Istanbul at the request of Abdul Hamit II to design the Ottoman National Exhibition in 1894. That project was ended by a devastating earthquake but he became the Sultan's favourite architect and the de facto successor to the Balyan Dynasty before he left Istanbul in 1909. Among his commissions was the extension of Sarkis Balyan's Şale Köşkü (page 69), the Imperial School of Medicine (page 84) and the Şeyh Zafir complex (page 68) which is regarded his masterpiece. He was also responsible for the Botter House and the Laleli Fountain (both on page 52) in Beyoğlu.

Sunset behind the Blue Mosque.

Barbarossa's death at the age of 80. His tomb, by Sinan, is on the opposite side of the square, and the nearby Naval Museum has a room devoted to Barbarossa. Known in Turkish as Hayrettin Paşa, the Mitylene-born corsair was already in control of Algiers when Süleyman renewed his father Selim's earlier alliance and made him his High Admiral.

Page 69
Şale Köşkü (c. 1880–1898)
Yıldız Park, Beşiktaş
Şale Köşkü, the most impressive of the Pavilions in Yıldız (Star) Park, was built in stages during the reign of Abdül Hamit II. The first sections were designed by Sarkis Balyan. Raimondo D'Aronco doubled the size of the pavilion with the north annexes built in 1898 for the second visit of Kaiser Wilhelm II.

Page 71
Kanyon (2006)
185 Büyükdere Caddesi, Levent
Kanyon is a joint venture of the Eczacıbaşı Group, whose core business is pharmaceuticals, and İş real estate. The award-winning design of the shopping centre, part of a multi-purpose complex that also includes a 30-floor office tower and a 22-floor residential block, is said to have been inspired by the Grand Canyon in Arizona, USA. It is the work of the Jerde Partnership of Los Angeles with the local firm, Tabanlıoğlu Mimarlık. Tabanlıoğlu is also the designer of what is to be the tallest building in Istanbul, Sapphire, due to open in 2009, and was responsible for the Istanbul Museum of Modern Art conversion.

Page 73
Aşiyan Museum (Built 1906, museum opened 1945)
Aşiyan Yolu, Bebek
Tevfik Fikret (1867–1915) was at one time Director of Galatasaray Lisesi (page 58) and for many years taught Turkish Literature at Robert College. In 1961, he was re-interred in the grounds of the Museum that stand on a terrace overlooking the Bosphorus.

The University of the Bosphorus (1971) (Robert College 1863–1971)
Boğaziçi University, Bebek
Robert College was founded by an American missionary, Cyrus Hamlin, and named for philanthropist Christopher Robert who provided the initial funding. Boğaziçi University was officially established when today's South Campus of 118 acres, including buildings, all facilities and personnel, was passed on to the Turkish government, on 10 September 1971. The University now has an enrolment of over 10,000 students, evenly divided by gender, in 12 faculties and schools.

Egyptian Consulate-General (1902–)
Mısır Başkonsolosluğu Yazlığı, Bebek
Although often attributed to Raimondo d'Aronco, it appears that an Austrian architect, Antonio Lasciac (1856–1946), played a major part in the design of this distinctive *yalı*. The deep mansard roof may have been inspired by a northern French chateau.

Page 74
Rumeli Hisarı (1452, restored 1953–1958)
Rumelihisarı Caddesi, Rumelihisarı
The fortress lost its importance on the fall of Constantinople and was used as a prison. It was damaged by an earthquake in 1509 and by a major fire in the 17th century. After years of neglect it was restored from 1953 to 1958 under the supervision of Cahide Tamer (1915–2005), one of the first women architects in Turkey, and a museum and open-air theatre were installed. Mrs Tamer was also responsible for the restoration of Yedikule Castle in 1959 (page 46).

THE OTHER SIDE: ISTANBUL IN ASIA

Page 77
Beylerbey Palace (1861–1865)
Abdullah Ağa Caddesi, Beylerbeyi
Built on the site of an earlier wooden palace destroyed by fire in 1851, Beylerbey was started on the accession of Abdül Aziz in 1861 and completed in 1865. It was the first work of Sarkis and Agop Balyan as heads of the family firm of

architects. Their neo-classical exterior houses a sumptuous traditional Ottoman interior.

Page 78
Küçüksu Kasrı (Commissioned 1856)
Çubuklu-Kavacık Taş Ocağı Yolu, Anadolu Hisarı
The palace was built in 1856 for Abdül Mecit I by Nikoğos Balyan, one of the family of Armenian architects responsible for many imperial mosques and palaces, on the site of an earlier wooden pavilion dating from 1752.

Page 79
The Selimiye Barracks (1826, enlarged 1842–1853, repaired 1963)
Kavak İskele Caddesi, Üsküdar
When Mahmut II abolished the Janissaries in 1826, he commissioned Krikor Balyan to build a new barracks on the site of a wooden barracks that the Janissaries had destroyed in their revolt in 1812, and named it for his predecessor, Selim III.

Crimean War Cemetery (Opened 1853)
Haydarpaşa Cemetery
The cemetery was founded as a burial place for British soldiers who died in the Selimiye barracks when it was used as a hospital during the conflict (1853–56), in which British and French forces supported Abdül Mecit I in his war against the Russians. There are about 6,000 graves of British soldiers who died (many as the result of a cholera epidemic) in the Crimean War and others who died in the two World Wars. The land was donated by the Turkish Government in 1855 and 1867 and is maintained by the Commonwealth War Graves Commission.

Florence Nightingale (1820–1910) spent three years at Selimiye, during which time improvements in nutrition and hygiene and the isolation of infectious diseases dramatically reduced the mortality rates of the sick and

wounded soldiers. On her return to England in 1857 she used her experience and statistical skills to help bring about radical improvements in both military and civilian hospital care.

Page 80
Maiden's Tower (1726, restored 1832, refitted 1998)
Kız Kulesi, Salacak, Üsküdar
The islet has a long history. The first fortress on the islet was built in the mid-12th century by the Byzantine emperor Manuel I Comnenus. A new tower built by Mehmet II (1451–81) was rebuilt after the earthquake of 1509 and functioned as a lighthouse. That burned down in 1710 and was rebuilt in 1726 when it was used as quarantine in a cholera epidemic. It underwent a major restoration in 1832 when the present baroque dome and flag-mast were added. The most recent facelift was in 1998. It is now a café and restaurant open to visitors.

Pages 82–83
The Atik Valide Mosque (Built 1570–1579, widened 1583)
Eski Toptaşı Caddesi, Toptaşı
The mosque is part of a great complex that includes a *medrese*, a hospital, a school, a public kitchen, a caravanserai and a *hamam*. It was built for Nur Bânu, the Graeco-Venetian wife of Selim II and the mother of Murat III.

Pages 90–91
Büyükada, Princes' Isles
In the Byzantine period the Princes' Isles archipelago was known as Papadonisia, the Isles of the Monks, for the many monasteries established there. The largest island became 'Prinkipo', Isle of the Prince, and later the entire archipelago became known as the Princes' Isles. Today Prinkipo, most populous of the nine Princes' Isles, is named Büyükada, meaning 'Big Island'.

A Dynasty of Architects
Ottoman architecture in the 19th century was almost exclusively the creation of the descendents of Bali Balyan, an Armenian immigrant who settled in Istanbul. His son **Krikor Balyan** (1764–1831), having trained in Paris, returned to become Mahmut II's Imperial Architect, for whom he designed the fine Nusretiye Camii, in a blend of baroque and French empire style, and the Selimiye Barracks (page 79). Krikor's brother **Senekerin** (1768–1833) was responsible for the Beyazıt Fire Tower (page 38). Krikor's son, **Karabet** (1800–1866), together with Karabet's son, **Nikoğos** (1824–1858), was responsible for the Dolmabahçe Palace (pages 66–67) and—with his second son, **Sarkis** (1835–99)—for Beylerbey Palace (page 77). Nikoğos, who with his brother studied at the Paris Ecole des Beaux Arts, branched out alone with the Mecidiye Mosque at Ortaköy (page 72) and Küçüksu Kasrı (page 78), and the two brothers together designed Çırağan Palace (page 68).

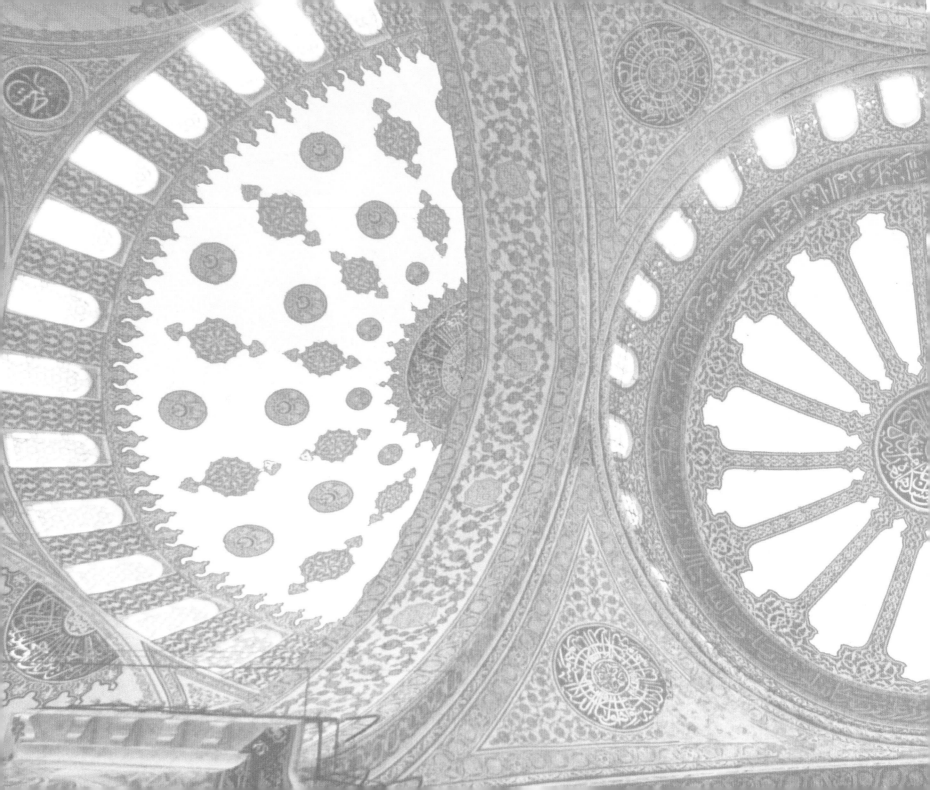